IMAGES
of America

WEST JEFFERSON

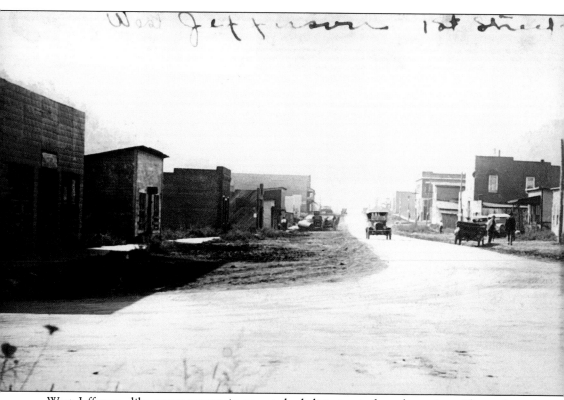

West Jefferson, like many mountain towns, had dirt streets for a long time. Shown here is Jefferson Avenue, the main street in the town. Note that most of the buildings, except the hotel at right, are wooden structures. This is a very early photograph, probably taken before paving of the streets had been completed. (Courtesy of Beth Ray Schroeder.)

ON THE COVER: Members of the West Jefferson Fire Department pose in 1962. They are, from left to right, (first row) Rex Morton, Sam Davis, Bailey Barker, Bradshaw Myers, Carl Graybeal, Bill Shatley, Bernard Graybeal, Chief Russell Barr, and Assistant Chief Walter Tucker; (second row) John Reeves, Earl Graybeal, Kyle Vannoy, Don Wiles, Sharpe Shoemaker, Paul Rumple, and Robert Barr. (Courtesy of John Reeves.)

IMAGES
of America

WEST JEFFERSON

Ashe County Historical Society

ARCADIA
PUBLISHING

Published by Arcadia Publishing
Charleston, South Carolina

Printed in the United States of America

Library of Congress Control Number: 2013944606

For all general information, please contact Arcadia Publishing:
Telephone 843-853-2070
Fax 843-853-0044
E-mail sales@arcadiapublishing.com
For customer service and orders:
Toll-Free 1-888-313-2665

Visit us on the Internet at www.arcadiapublishing.com

CONTENTS

ACKNOWLEDGMENTS

The Ashe County Historical Society would like to thank its board of directors for sponsoring this book project. The society would like to especially thank president Jerry Brown for his efforts to facilitate putting the work group and the book together. We also want to thank the Town of West Jefferson for its support and the use of the town hall for meetings and planning. We especially thank Mayor Dale Baldwin for his support and for attending meetings to aid us in identifying photographs and captioning them. The Book Committee, or authors, for this project were Lonnie Jones, Brian Jones, John Reeves, Carol Williams, Gary Poe, Anne McGuire, JoAnn Woodie, Joy Campbell, Jerry Brown, and Dale Baldwin. We would like to thank the following people for the photograph contributions used in putting this book together: Gene Hafer, Beth Ray Schroeder, the Wiles family, Mary McIntyre, Jerry Brown, Museum of Ashe County History, Ed Reed, John Reeves, Dale Baldwin, and many others. We thank the Book Committee for its many hours of hard work.

INTRODUCTION

The town of West Jefferson did not exist in 1900. That makes this town "new" compared to most towns in North Carolina, and indeed it is "new" by the age of towns in the 13 original colonies. It is located in the Appalachian Mountains of North Carolina, in an area considered so remote by many that it earned the nickname the "Lost Province." Recently, historians in the area started rejecting that name and connotation, as evidence was found of much outside contact and trade with other places. Among the indicators of this contact are methods and aspects of education, as well as the quality and place of origin of furniture and merchandise found in the area.

In 1900, where West Jefferson is now, a thriving farm community of five or six families existed. These families had for the most part owned the land, in a valley between Mount Jefferson and Paddy Mountain, for many years. This land had originally been part of a large grant to Benjamin Cleveland of Revolutionary War fame. The original residents could not have imagined what the next 15 years, and indeed the next 113 years, would bring. Those families bear the names of residents who appear throughout this book, as many stayed on and became part of the new town. Hardworking families such as the Parkers, Fletchers, and Hartzogs, as well as two Graybeal families, lived there. These small but prosperous farms had nice orchards with cherry trees and beautiful gardens. The valley was located only two miles from Jefferson, the county seat, with several stores, churches, schools, and a post office operating there.

But, far away in bigger towns, men who knew about the timber-rich land in the Virginia and North Carolina mountains were considering ways to harvest that wealth and to haul away the products grown in the area. There was talk of a railroad from Tennessee; others looked at a rail coming in from Virginia through Grassy Creek; and others observed what was already happening in Abingdon, Damascus, and the Grayson Highlands area. Although the valley at West Jefferson consisted of steeper and rougher terrain, a rail line would pass through the very heart of the timber stands near Whitetop Mountain and down into Ashe. The railroad men, particularly W.E. Mingea, along with some successful and forward-looking men in Ashe County, saw this as an opportunity when the Abingdon Line decided to locate its newest depot in that small farm-filled valley. This decision to bypass Jefferson hinged on the extra $50,000 it would have cost to go that route, and for a time created feelings of ill will in the county. But, it would appear that many successful Jefferson businessmen became part of this new effort, helping the new town to grow.

Several men, including Thomas C. "Tam" Bowie (who would soon become Speaker of the House in North Carolina), H.C. Tucker, and E.A. McNeil, formed what was to become the West Jefferson Land Company and began buying property for what would, they hoped, become a new town. They petitioned the North Carolina Legislature, and a charter for West Jefferson was granted on February 9, 1915. It has been written that the first train arrived in West Jefferson that same month. The town limits were to be a one mile square in all directions from the new depot. A successful land sale was held, and West Jefferson was born. When the engine steamed into the fledgling town in 1915, land offices, lumber companies, banks, and other businesses catering to rail traffic had already started elbowing each other for space beside the tracks.

The Virginia Creeper train, planning for which began in 1914, began making regular trips in 1915, and the town started growing. A hotel was built to handle the influx of workers for the train, sawmills, and other businesses. That wooden structure burned in 1916. It was rebuilt in 1917 as a brick structure, and it remains perhaps the most recognizable building in West Jefferson today. From 1915 until the early 1930s, the train and it daily runs to haul lumber and wood products caused rapid growth in the town and the county. As the timber ran out, the train ran less frequently, at first on fewer days weekly, and, finally, on only one day a week. Passenger traffic was never profitable, and in 1977, the train made its last run.

The first mayor of the town was Donnelly Blevins, and R.C. Barr, W.F. Hartzog, Isaac Faw, and Amos Graybeal were the aldermen. Other businesses were launched and, by the mid-1920s,

many of those were in brick buildings. The lumberyard close to the train tracks on Back Street was Harrison Tucker's effort. He also had a hardware store and operated Tucker's Hotel. Tucker was also a lumber purchasing agent for the railroad for some time. "Tam" Bowie, in addition to his political career, was a partner in the Ashe Hardware business. R.C. Barr had constructed the original West Jefferson Hotel and rebuilt it with partners in 1917. He had several sawmills and, eventually, started the Phoenix Chair plant, which operated in West Jefferson for many years. John Richardson owned an early store and boardinghouse, John A. Weaver had a store and even a taxi service, and Isaac Faw had a livery stable. By the 1920s, there was considerable business in the town, with from eight to ten merchants living in West Jefferson.

From the 1930s to 1950s, the town continued to grow, mostly because of industry and trade, as the train was running only once weekly and the timber industry was nearly played out. Parker Tie, Dr. Pepper Bottling, Burgess Furniture, McNeil's Department Store, the West Jefferson Theater, Graybeals Drug Store, Ray's Drug Store, and Badger Funeral Home became thriving businesses. A newspaper, the *Ashe Recorder*, was replaced by the *Skyland Post*, which operated for many years in West Jefferson. Several doctors were located in the town, among them B.E. Reeves, Cicero Gambill, Edgar Dow Jones, Jack Hunter, and Ritz C. Ray. A tobacco warehouse was built in the 1940s to accommodate what had become the largest agricultural commodity in the area. Previously, the train and trucks took tobacco to Abingdon, Virginia, to market. Kraft Cheese became a long-term industry in the town; many smaller cheese plants had existed in the county as a whole, but this business continues to thrive today, although not as a part of Kraft Foods. The town became the retail center of the county. Many small country stores existed along the highways and byways and did well until the 1960s, but Ashe County shoppers wound up in downtown West Jefferson for most items. The town size as originally set by the 1915 charter changed, especially in the past few years. It now reaches into parts of the Beaver Creek community and to the new shopping area containing a Walmart.

A school existed within a short time of the town's charter. An old deed in possession of the Ray family shows a planned school when the land for the town was originally sold. The new school actually was located behind what is now the Badger Funeral Home. The funeral home building and the West Jefferson Community building started out as part of that school. In early days, there were dormitories on-site, and records of the Ashe Baptist Association show the school to have been started by that denomination. It was taken over by the state system, and the school continued as an elementary and high school until Beaver Creek High School was built. West Jefferson Elementary continued until it was consolidated into Westwood Elementary and with Fleetwood and Elkland more recently.

There are several churches in West Jefferson. The Methodist, Baptist, and Presbyterian churches located in the main part of the town are the most prominent. These three have beautiful buildings, are well attended, and have existed in the town from its early days. There are several other smaller churches located in town, including Calvary Baptist, West Jefferson Church of Christ, and the Real Life Church.

With the exit of the train in 1977, the coming of better roads and access to the county, the loss of industry in the county as a whole, and the loss of several businesses downtown, there was a downturn in the local economy in the 1970s and 1980s. Many small towns saw this happen, but West Jefferson responded positively in the 1990s, looking to make the town a location for many tourist-oriented businesses. Artists' shops, tourism-driven shops and restaurants, and antique stores and other retailers now line the streets. Christmas in July is a festival that draws crowds of people. Recently, the addition of an Antiques Fair, alongside the work of the local arts council, has indeed made the town a destination, making once empty parking spaces hard to come by these days. The town has several annual events that draw people to these stores and to Ashe County and its natural beauty.

We believe this book showcases the growth and change in our town and especially the people found there. They were and are hardy, adaptable, and strong, and they changed along with their town to make it what it is today.

One

THE BIRTH OF A NEW TOWN

Think of a rural mountainous area in 1914, and a small valley filled with small farms. Those farms have provided their owners with their only means of earning a living for generations. Some of the families lived there during the Civil War, or earlier, and the land was passed from father to son. But in 1914, the train came in, not to the county seat of government, but to that valley where the farms and cherry and apple orchards were. A rail company was encouraged by the country's largest timber supplier to build tracks through the county and a depot right in the middle of that small valley. Additionally, several wealthy men are knocking on the doors of the farmhouses, wanting to buy land so that a new town can be built around the depot. Many of the families chose to stay and help build the town of West Jefferson.

Those first years must have been hard, but exciting. Small stores and boardinghouses sprang up very quickly, and workers around Ashe County moved with the railroad to build these, taking up residence in the boomtown being created almost overnight. Apparently, a larger wooden hotel was built and operated as the tracks came into town. The rail line then expanded on to Bowie (Fleetwood) and Elkland (Todd). General stores, selling groceries, farming supplies, mining supplies, clothing, and furniture, were going up on new streets within the one-mile-square around the train depot. This chapter shows in photographs the start of the town of West Jefferson.

West Jefferson is a prime example of a timber or railroad boomtown, but, in the eastern United States, it was rare for this to happen in the 20th century. All the profitable timber was cut down, but the town still grew. The businesses and town expanded as the population in the county dwindled. This is a testimony to the hardy nature of the people who settled the town, and to their willingness to adapt.

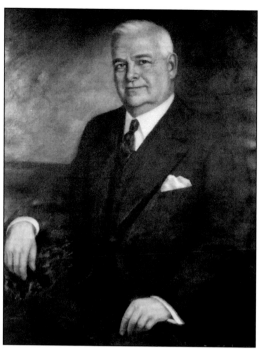

Thomas Contee "Tam" Bowie has been given much credit for the establishment of the town of West Jefferson, being one of several businessmen who formed the West Jefferson Land Company in 1914. As an important legislator, he was instrumental in obtaining a charter for the new town. He built his home and businesses in West Jefferson. This portrait, made by Boris B. Gordon in 1944, is owned by the current mayor, Dale Baldwin. (Courtesy of Brian Jones.)

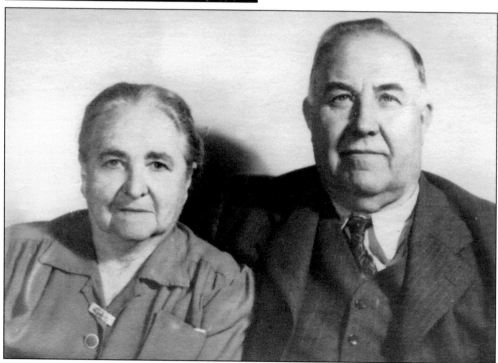

Harrison C. Tucker, pictured with his wife, Martha, was another Ashe citizen who partnered in the West Jefferson Land Company, along with Tam Bowie and E.A. McNeil. Tucker had been heavily involved in the lumber business and was later a lumber agent for Norfolk & Western. He moved to West Jefferson and owned several businesses. (Courtesy of the Ashe County Historical Society.)

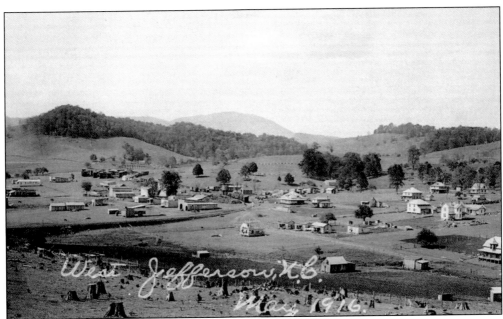

West Jefferson, N.C. May, 1916.

This early photograph, taken about 1916, shows West Jefferson just one year after it was chartered. Note, at center, the train sitting in the middle of the town. It is on the tracks just past the current location of the First Baptist Church. West Jefferson would not have become what it is without the railroad, and it grew rapidly once the train started running daily from Abingdon to West Jefferson. (Courtesy of Jerry Brown.)

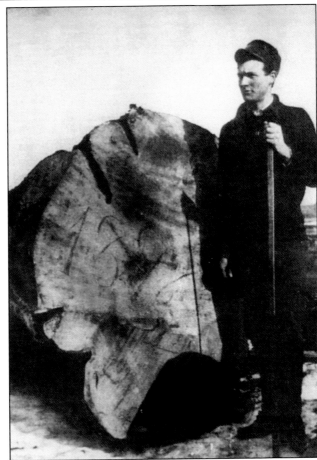

Shown here is Luther Hassenger, owner of the Hassenger Lumber Company. He indirectly contributed to the train coming to the area and the town being built. His company, which cut and shipped lumber and wood products all over the world, at one time was the largest producer of lumber in the United States. Note the size of the log he is standing next to. (Courtesy of the Ashe County Historical Society.)

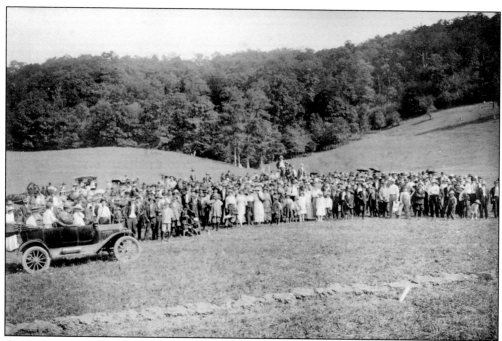

On February 9, 1915, after the North Carolina Legislature issued a charter for the new town, the West Jefferson Land Company scheduled a land sale for the property contained in the survey for the new town. Here, a large crowd has gathered for this very unusual event. Records at the Ashe County courthouse show that the sale was successful. Sales continued over the next few years. (Courtesy of John Reeves.)

This is Mrs. A.E. Graybeal's check for $638.85, for the purchase of a lot or lots on September 4, 1915. The check is made out to an auction firm, the L.M. Neas Company, which handled the land sale. Graybeal was Daisy Burkett Graybeal, the wife of Amos Graybeal. They were one of the five original families who lived and farmed before the town was built. Their homeplace still stands in West Jefferson. (Courtesy of John Reeves.)

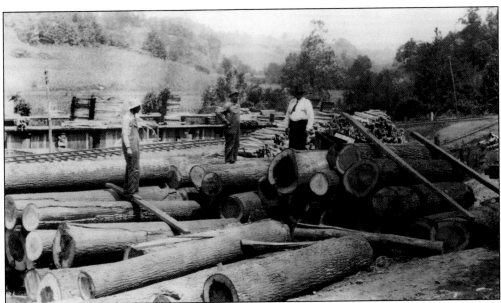

The Town of West Jefferson was built as a result of the railroad locating its depot on a specific site. But the train came and stayed only as long as the timber made the daily trips profitable. From 1914 until 1933, the industry was lucrative because of the area's natural resources. Sawmills sprang up all over the area, such as the one shown here, a larger one near Smethport. (Courtesy of Pete Eller.)

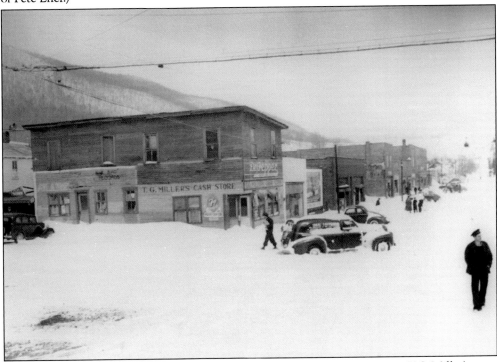

This 1942 photograph depicts a winter scene at the downtown intersection. T.G Miller's store was on the corner where the chamber of commerce is located now. This view is of Jefferson Avenue, looking toward Smethport Hill. (Courtesy of Calvin Miller.)

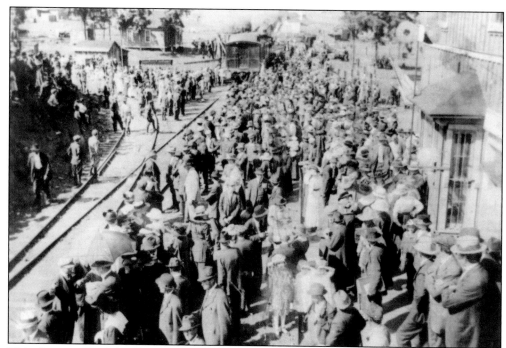

This photograph of the West Jefferson depot was reportedly taken when the first train arrived, sometime after February 1915. Work on the depot and the tracks leading there—and through Ashe County before ending in Elkland, near Watauga County—had begun in early 1914. The tracks were built in stages, first to Tuckerdale, then Lansing, Warrensville, Smethport, and into West Jefferson. (Courtesy of the Ashe County Historical Society.)

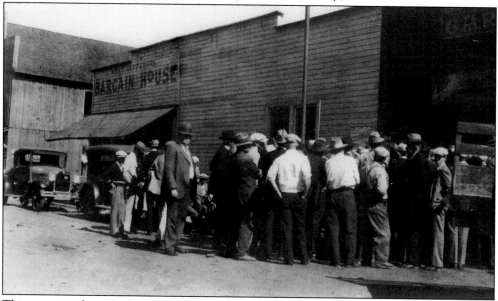

This structure, housing Bargain House, an early business in West Jefferson, is representative of the buildings in the 1910s, 1920s, and early 1930s. The gathering may be for a political meeting of some type in front of these stores. Thomas C. "Tam" Bowie is standing left of center, in a suit and hat, facing the camera. (Courtesy of Pete Eller.)

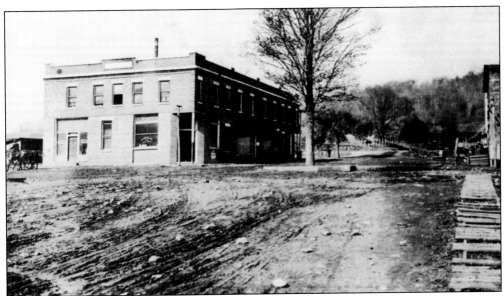

The West Jefferson Hotel, in the center of town, has been the location of many past businesses. It is easily the most recognizable landmark in town. Built first by R.C. Barr as a wooden structure, it burned down in 1916. It was rebuilt in its present form in 1917. The hotel was one of several in the booming train days, but it later housed a bank, doctors' offices, a pawnshop, and restaurants. (Courtesy of JoAnn Woodie.)

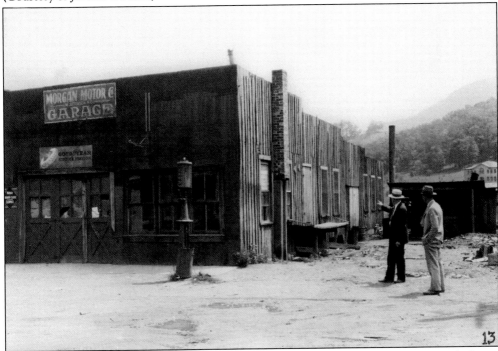

Another very early business in West Jefferson was the Morgan Motor Company, a dealer in Goodyear tires. This business benefited from the railroad's existence. Ashe County citizens were brought into the modern world by the ability of trains to transport cars and other modern conveniences to town. (Courtesy of Pete Eller.)

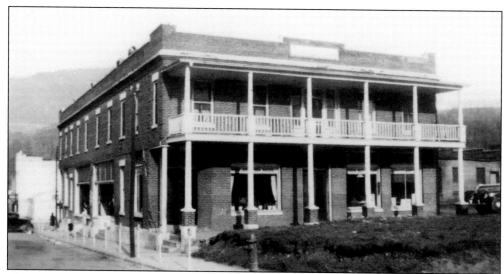

The West Jefferson Hotel is seen here in the mid-1940s. This view is of the back of the building, near the train depot location. The level of the ground in the back lot has been lowered considerably since the time of this photograph, which was taken by Dale Baldwin, the current mayor of West Jefferson. (Courtesy of Dale Baldwin.)

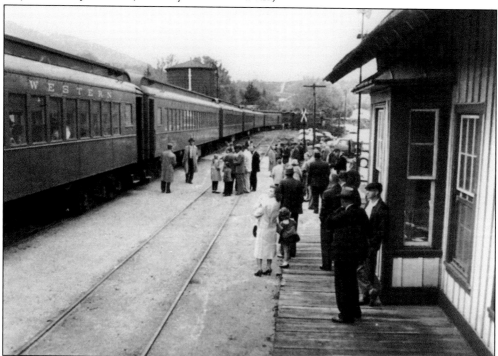

The Virginia Creeper train stops in West Jefferson in the 1930s. After 1933, the train still hauled timber products, but far less was available for harvest. The train was mainly a freight train, supplying the businesses of West Jefferson and Ashe County with products that were hard to bring in over the mountainous roads. The train carried passengers at times, mostly within the county; it was the connection to places farther away. The number of passenger cars shown here is unusual. (Courtesy of Pete Eller.)

Two

BUSINESS AND TRADE

Starting in 1915, business and trade in West Jefferson were dictated by the demand of the railroad. There was nothing except a valley with farms; then tracks were laid to the future site of a depot in the center of what is now West Jefferson. Immediately, men were hired or brought in to build the depot, and the tracks to Todd were begun. The men building tracks, the depot, and the first buildings in the community required places to shop, eat, sleep, and recreate.

The second phase of the town's growth took place when citizens from Ashe County came to start stores, boardinghouses, and other shops. Later, the town expanded as it became a shopping area for the whole of Ashe County. One of the first businesses was the large hotel, located in the middle of town, beside the depot, which accommodated workers the train brought and people who traveled here by train. The town spread from there, along the tracks to Smithey's Store.

Boardinghouses sprang up around town, including the Richardson home on Third Street. That house still exists today, across the road from the Methodist church. The cheese plant was established around 1919. John Weaver opened several businesses starting shortly after 1915, and many of his buildings are still used today. Robert C. Barr was a partner in the hotel and owned what grew to be a large furniture plant. It was eventually sold to the Thomasville Furniture Company.

Places like Blackburn's Department Store, McNeil's, Burgess Furniture, Dr. Pepper Bottling, the Parkway Theater, and the Ford Motor dealership are remembered as mainstays of the town's commercial district. Today, the town is a center for artists' shops, which reach out to tourists. It still is the center of commerce in the county. The vestiges of the train and the influence it had are still seen in these photographs, and the buildings, filled now with other enterprises, still remind one of those earlier days

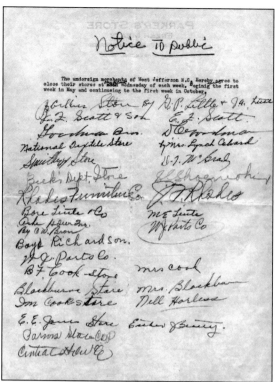

This is an agreement made by all West Jefferson merchants to close their stores every Wednesday at noon. The agreement, announced to the public, was effective for all participating merchants from May 1 until October 1 every year. Later, this became a year-round policy, and it continued through the early 1980s. (Courtesy of the Ashe County Museum of History.)

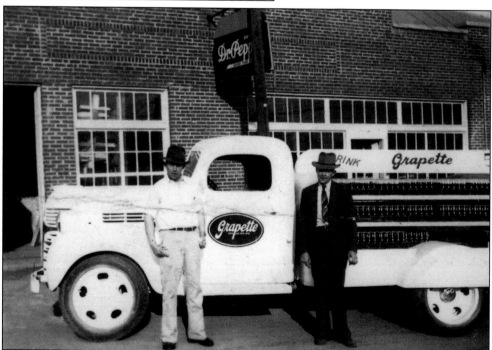

A Dr. Pepper Bottling Company truck is loaded with drinks bottled in town and ready for delivery. Carl Colvard (left) and H.R. Vannoy pose beside the truck on North Third Street. (Courtesy of the Ashe County Public Library.)

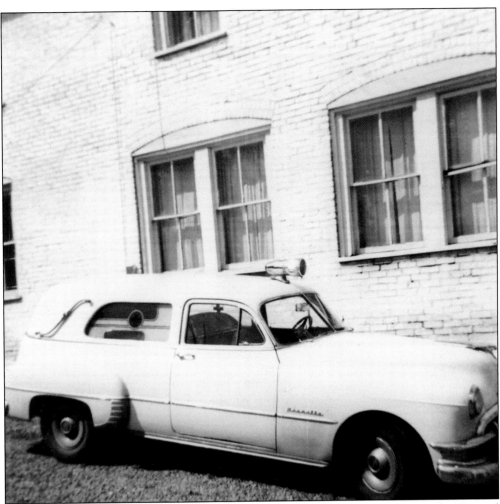

This is an early photograph of Badger Funeral Home and one of its ambulances. Badger Funeral Home, West Jefferson's oldest business, is in fact the oldest in Ashe County and the sixteenth-oldest in the state of North Carolina. This car was used by the company in operating the countywide ambulance service. Badger Funeral started doing business in Ashe County in 1854. (Courtesy of Bill Badger.)

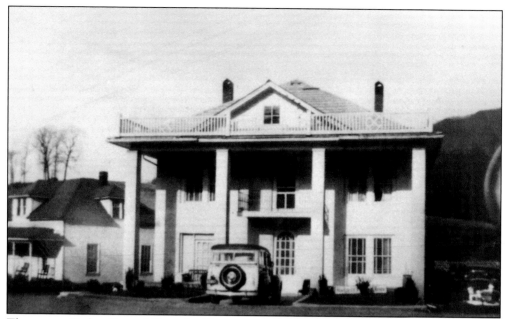

The current Badger Funeral Home building started as a dormitory for the West Jefferson School. When the institution became a public school and dormitories were no longer needed, this building was sold and became the new location of the funeral home. The Badger family has played a major role in the growth and life of the town for many years. (Courtesy of Bill Badger.)

The funeral home, seen here in the early 1960s, stands at the lower, southeast end of Jefferson Avenue. William Badger, who moved to West Jefferson from Virginia in 1854, started the funeral home after being in a successful casket-building business for several years. (Courtesy of Bill Badger.)

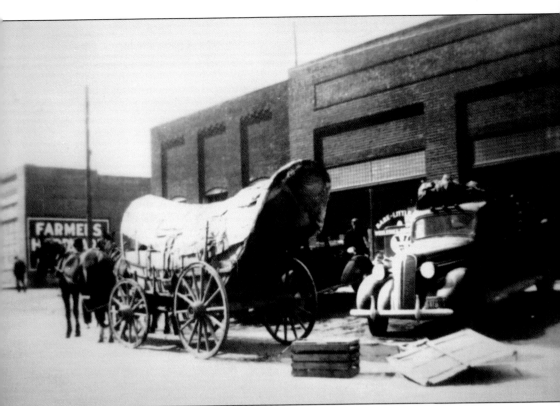

This photograph shows Main Street, just above the West Jefferson Hotel. These customers, one in a horse-drawn wagon and another in a truck, are patronizing Bare & Little, a company that did business for many years in West Jefferson. Begun in 1922 by William Bare and Mont Little, this firm sold farm supplies and did wholesale business with other merchants in the town and county. (Courtesy of the Ashe Historical Society.)

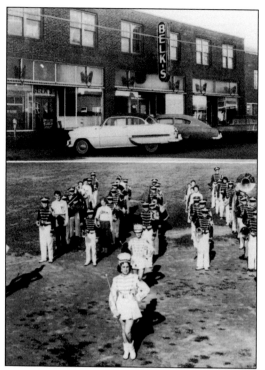

In the mid-1950s, Belk's West Jefferson store was perhaps the largest retailer with a presence in town. Initially located farther down the street in smaller quarters, the store is seen here after it had moved and expanded into its full size. Belk's remained at that location until it closed in the mid-1980s. Also shown here is the West Jefferson High School band, perhaps performing in a parade. (Courtesy of the Ashe County Public Library.)

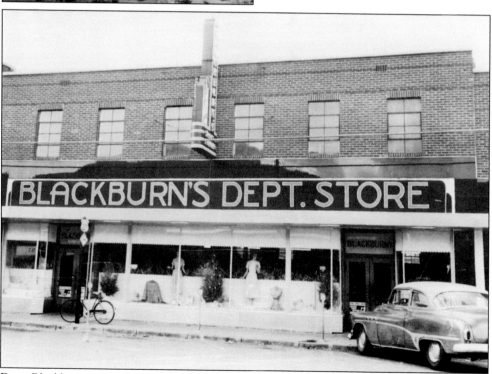

Don Blackburn opened this department store in downtown West Jefferson on north Jefferson Avenue. It later became Ashley's Department Store. (Courtesy of the Ashe County Historical Society.)

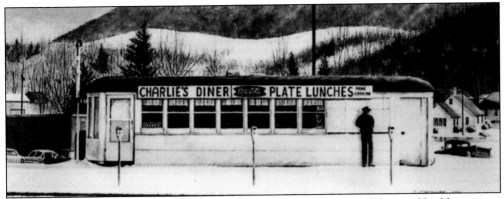

Charlie's Diner was a unique restaurant in the region. Occupying a mobile metal building, it was one of the best-known sites in town. Charlie Davis was the owner. (Courtesy of Jerry Brown.)

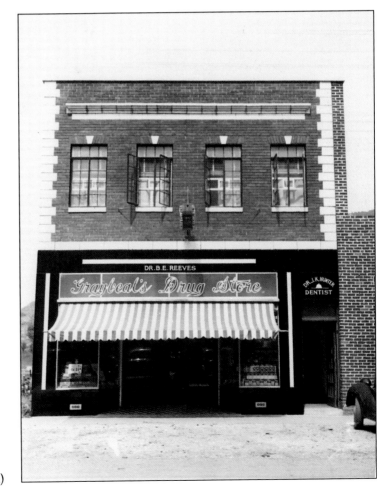

Graybeal's Drug Store, established by Carl and Ruth Graybeal, was a longtime presence downtown. Dr. B.E. Reeves had an office in the back of the drugstore, and Dr. J.K. Hunter, who was a dentist, had an office upstairs. (Courtesy of the Ashe County Public Library.)

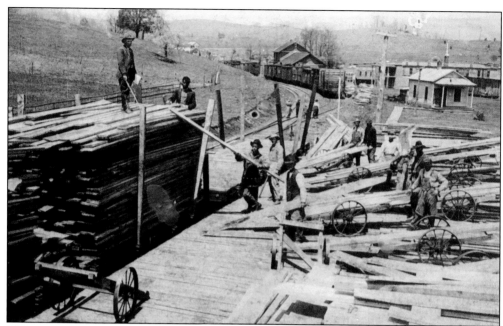

The main products the train carried until the mid-1930s were lumber and other wood items. The train came to town and picked up what had been cut and readied for shipment. This scene shows men working to load lumber onto flatcars. The lumber came from sawmills all over the county. This appears to be near the location of the stockyard or the tobacco warehouse. (Courtesy of the Ashe County Historical Society.)

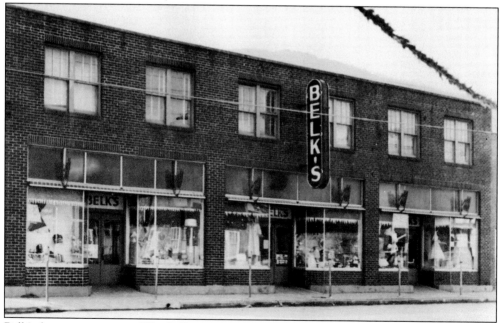

Belk's department store in West Jefferson was one of a few businesses in town that were part of a larger outside corporation. Sharpe Shoemaker was a manager when this photograph was taken. The Vannoy family owned the building. The small building to the right had housed the post office after it moved out of the hotel. (Courtesy of the Ashe County Historical Society.)

Note the gravel street beneath the feet of these two young servicemen. The movie theater on the right is still on this block, but it has moved down the street one building, to where the Ford dealership long stood. In the distance, at the end of the street, is Badger Funeral Home. The last building on the left side of the street is the pipe factory, which made pipes out of Laurel burls or roots. (Courtesy of the Ashe County Historical Society.)

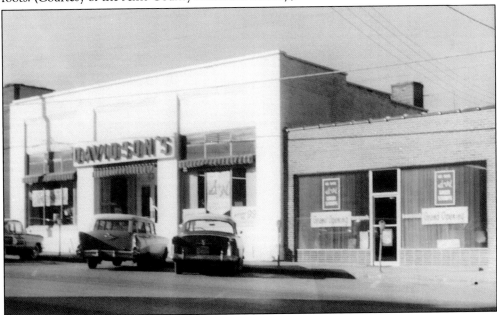

Davidson's department store on Main Street in West Jefferson was operated for many years in this same location. It had previously been operated by Inez Davidson's father, Ed Jones, at a different location. There is an S&H Green Stamps store in the small part of the building at right. The Davidsons later had a shoe store there. Davidson's later moved out of town to the location currently occupied by O'Reilly's. (Courtesy of the Ashe County Public Library.)

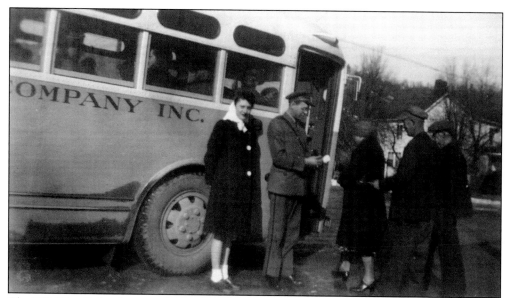

The E.O. Woodie bus line operated in North Carolina and three other states. The bus station was located in the hotel though the late 1960s. Woodie, a well-known West Jefferson entrepreneur, had purchased the hotel and operated it, with several businesses renting from him. (Courtesy of the Ashe County Historical Society.)

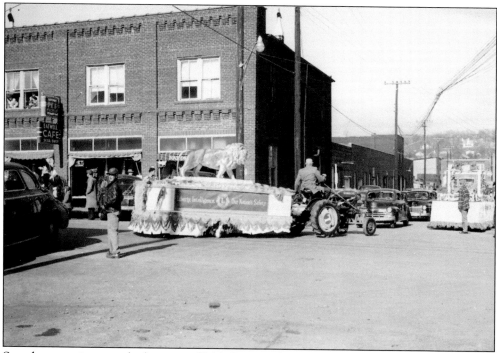

Seen here turning past the location of Mo's Boots is the Lions Club float in a 1945 parade. It is said that the parades held in town during the late 1940s drew large crowds. East Main Street, with a view of Badger Funeral Home, is the terminus of the parade. (Courtesy of the Ashe County Public Library.)

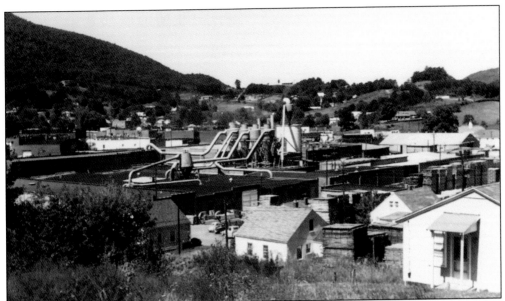

The view in this photograph overlooks the Phoenix Chair plant in West Jefferson. At one time, this was one of the largest employers in Ashe County and certainly the largest in West Jefferson. It was begun, owned, and operated by Roberts C. Barr, who was an integral part of West Jefferson for many years. He was an owner of the Ideal Laundry & Dry Cleaners, the old hotel, and West Jefferson Wood Products. This factory was sold and became part of Thomasville Furniture until it closed. (Courtesy of the Ashe County Public Library.)

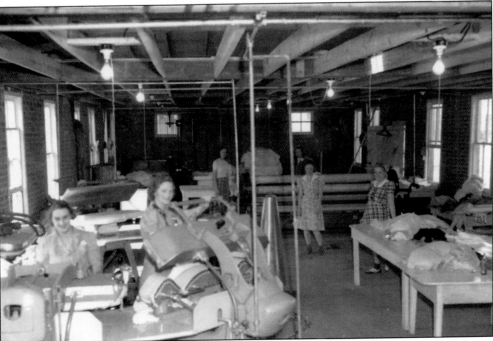

Robert Barr also owned the Ideal Laundry business. This interior photograph shows employees of the laundry at work. This was a successful enterprise for many years. (Courtesy of the Ashe County Public Library.)

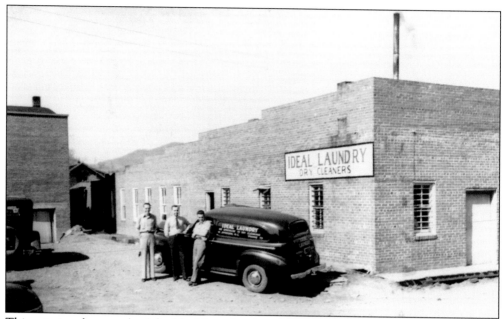

This exterior photograph of the Ideal Laundry shows a delivery truck and employees posing for the camera. One wonders why current businesses no longer deliver, as Ideal did, and how they could in those days. (Courtesy of the Ashe County Public Library.)

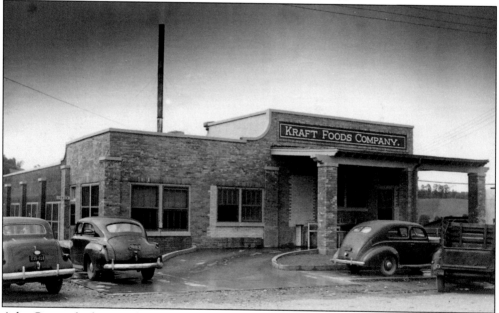

Ashe County had many cheese-making locations over the years, a natural consequence of the great number of dairy operations in the county. There were cheese plants in Grassy Creek, Lansing, and West Jefferson. Ashe County Cheese still operates at the location shown here. Located on West Main Street, it was a Kraft Cheese plant from about 1930 until it was sold to private owners, the Hazelwood family, in 1975. It has been a successful business since then, falling under the ownership of several different people. (Courtesy of the Ashe County Historical Society.)

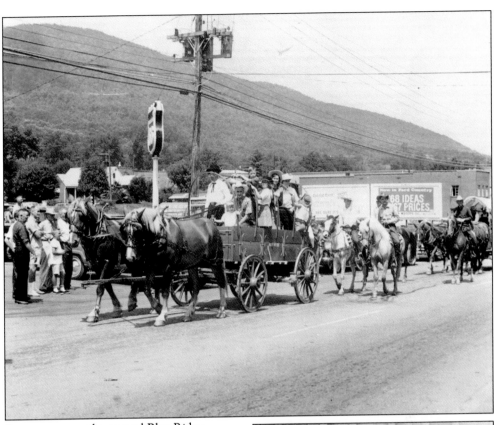

For many years, the annual Blue Ridge Wagon Train started in Wilkes County, trekked into Ashe County, and paraded through West Jefferson on a Saturday. This well-attended event offered entertainment for those on the trip and for the people who dropped by the nightly camp. Here, a wagon with several passengers and a couple of riders pass through town near the old location of the Chevrolet dealership. (Courtesy of Jerry Brown.)

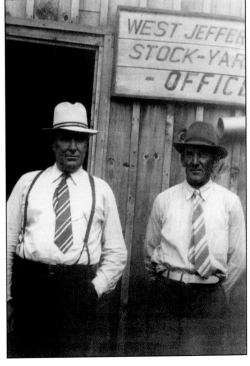

Shown here are Charlie Mahala (left) and A.M. Reeves. The men are standing in front of the West Jefferson Stockyard, where they worked. Many people remember this place for the special restaurant that was located there in later years. (Courtesy of John Reeves.)

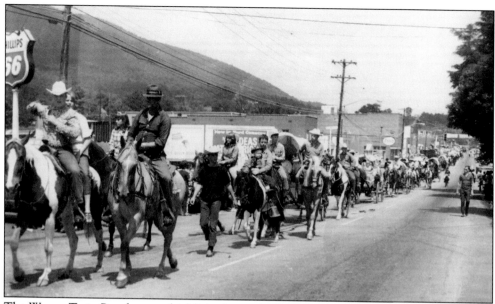

The Wagon Train Parade was a highlight for residents throughout the county. This view, from the former location of the Twin City Chevrolet dealership, looks down the entire length of Jefferson Avenue as the parade stretches into the distance. People came from neighboring towns and communities to participate in the Wagon Train and to spend Saturday in West Jefferson for the parade. (Courtesy of Jerry Brown.)

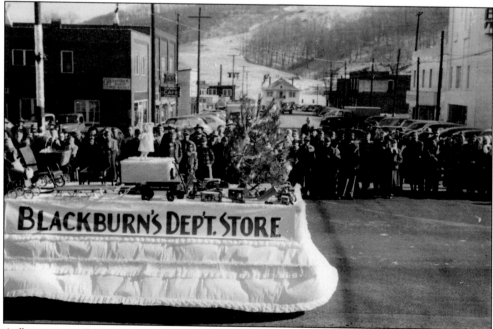

A float prepared for the parade by Blackburn's Department Store rides along Jefferson Avenue at the intersection with Main Street. The decorations and items on the float indicate that this is a Christmas parade. Note the blanket of snow in the background and the heavy coats on the people watching the parade. Badger Funeral Home and East Main Street are also in the background. (Courtesy of the Ashe County Public Library.)

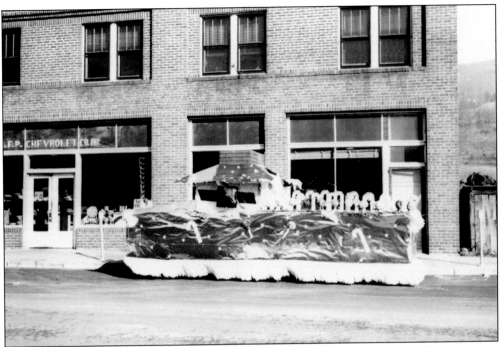

Santa Claus rides on the last float of a Christmas parade in the late 1940s. The float is passing the original location of the Chevrolet dealership in West Jefferson. (Courtesy of the Ashe County Public Library.)

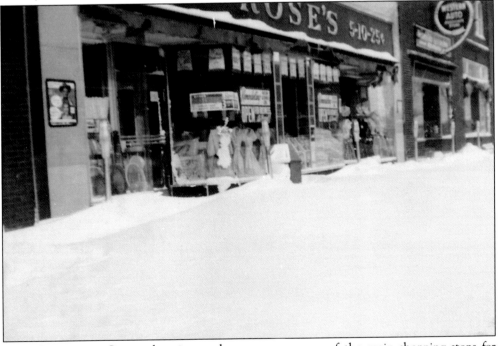

Rose's Department Store, when it was downtown, was one of the main shopping stops for many people in Ashe County. It was located on Jefferson Avenue for some time before moving completely out of town. (Courtesy of the Ashe County Public Library.)

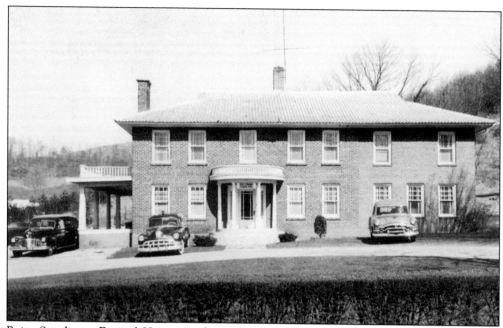

Reins-Sturdivant Funeral Home was located just above the Bantam Chef location, near the offices of the *Skyland Post*. All that is left of this building are the garages where the hearses were parked. (Courtesy of the Ashe County Historical Society.)

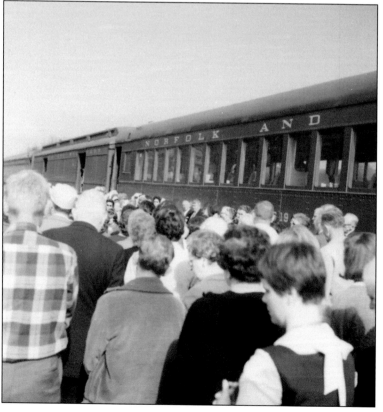

Passenger business was not good in the last years of the Virginia Creeper. Partly to encourage ridership and partly as a tourist event, the Norfolk & Western Company, in cooperation with local citizens, organized an annual trip in the fall from West Jefferson to Abingdon, Virginia. The fall foliage in the mountains was the main attraction for this excursion. Here, passengers board the train for the start of one of those trips. (Courtesy of the Ashe County Historical Society.)

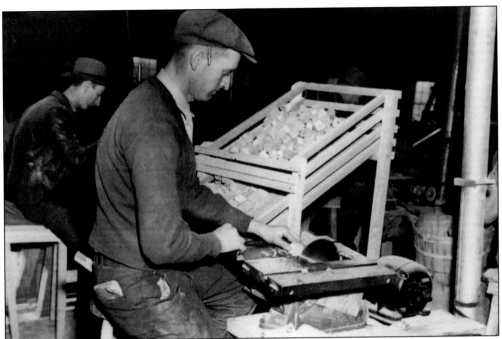

Laurels burls are the hard, twisted roots of Mountain Laurel, which grows plentifully in the area. These burls were harvested and cut up into smaller pieces, then shaped into smoking pipe bowls in a small manufacturing plant in West Jefferson. (Courtesy of the Ashe County Public Library.)

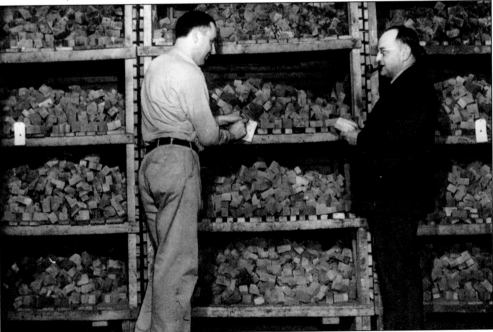

These storage bins are full of pieces of laurel root, ready to be cut into pipes. This factory operated for several years in the area near the current cheese plant in West Jefferson. (Courtesy of the Ashe County Public Library.)

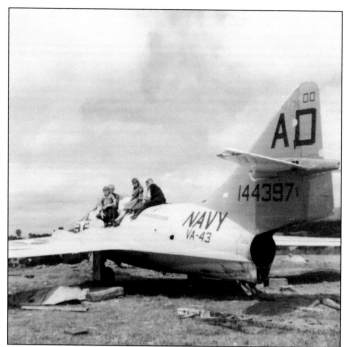

The Air Force donated this plane to West Jefferson, and it was placed in the area at West Jefferson Park close to the current library. It was there for many years and was quite an attraction for many small children and adults. This large area of the park, now the ball fields, was used for passing circuses and carnivals, which set up there for weeklong performances. (Courtesy of Jerry Brown.)

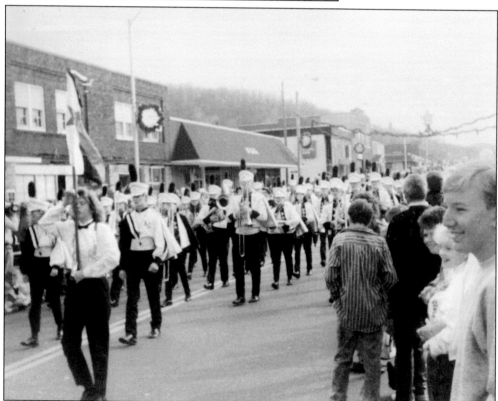

In the 1990 Christmas parade, the Ashe Central High School Marching Band walks down the street, near the intersection of Jefferson Avenue and Main Street. (Courtesy of Lonnie Jones.)

This is an early, downtown location of the West Jefferson Fire Department. The sign on the door reads "W. J. Fire Dept." (Courtesy of the Ashe County Public Library.)

This 1940s photograph was taken from in front of McNeil's. Seen here is the West Jefferson Hotel, with a member of the McNeil family posing in the street. Note the porch on the side of the hotel. (Courtesy of the McNeil family.)

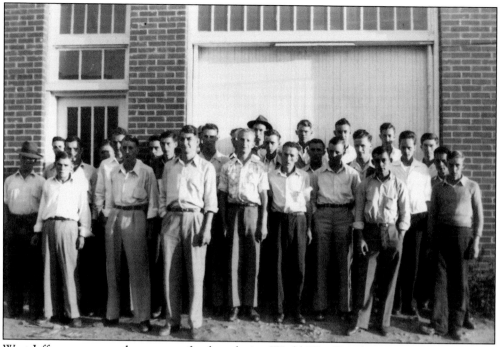

West Jefferson men ready to report for duty during World War II gather to await a bus leaving town. The man out front, third from left in the front row, is identified as Gilmer Paisley from Grassy Creek. This location seems to be the fire department building in West Jefferson. (Courtesy of the Ashe County Public Library.)

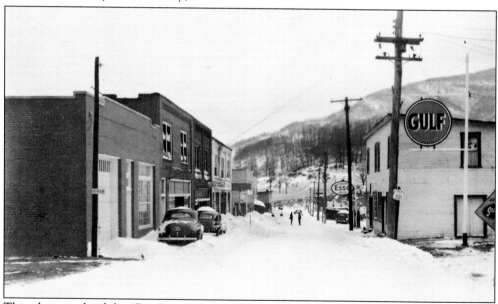

This photograph of the "Big Snow" (written on back of image) of 1960 shows a view of East Second Street looking toward the current Ford dealership. On the left side of Second Street are C&C Recapping and Dollar Electric, formerly the location of Badger Funeral Home. The Gulf sign is at Flo's, a service station, and the wooden building beyond it was at one time a bowling alley and, later, a used shoe store. (Courtesy of the Ashe County Public Library.)

Ray Drug Store is depicted here in 1951. The store was the property of Dr. Ritz Clyde Ray and his family. The doctor was a leading Ashe County citizen. (Courtesy of the Wiles family.)

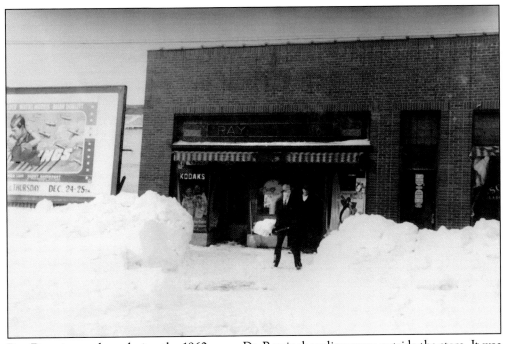

Ray Drug is seen here during the 1960 snow. Dr. Ray is shoveling snow outside the store. It was owned by Clifford Ray, his brother. Note the movie billboard beside the store on an empty lot. Today, the lot is the location of the chamber of commerce offices. The building behind the billboard was Parson's Store. (Courtesy of the Ashe County Public Library.)

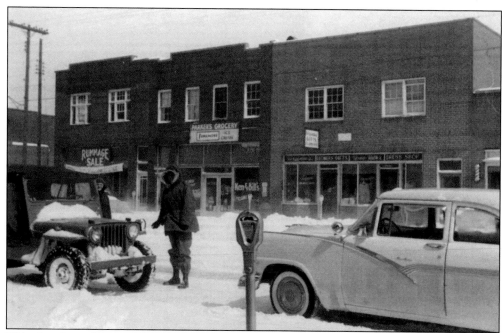

Wiles Jewelry is shown in this photograph, furnished by the daughters of the owner, Don Wiles. This image was taken during the so-called Big Snow of 1960. Note the Army or National Guard Jeep. Service members were in the county, offering help to the many people trapped in the snow. The snow began falling in February and lasted for weeks, with many roads impassable throughout the mountain area. (Courtesy of the Wiles family.)

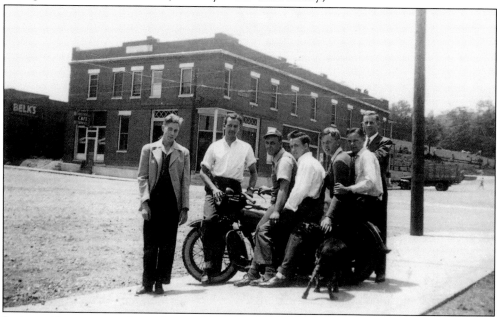

Posing with a motorcycle in the town center are, from left to right, Harold Dollar, Edwin Weaver, Jim Miller, Dean Hurley, Bill McNeil, and two unidentified men. The old hotel is in the background, as is the first location of Belk's of West Jefferson. This photograph was taken around 1945. (Courtesy of the Ashe County Public Library.)

In Ashe County, the largest agricultural cash crop became tobacco after the timber stands were depleted. Burley tobacco was grown on every small farm, each having an allotment. In the early days of the railroad, tobacco was hauled to Abingdon to be sold. By the 1950s, West Jefferson had two burley markets or warehouses. Pictured here is one owned by the Taylor family and located on Long Street. The other warehouse was at the top of Radio Hill, near the Skyline Telephone buildings. (Courtesy of the Wiles family.)

The Hotel Tucker of West Jefferson was another business operated by H.C. Tucker, who was one of the original members of the West Jefferson Land Association. This establishment was located near today's West Jefferson Park, across South Church Street. (Courtesy of the Ashe County Public Library.)

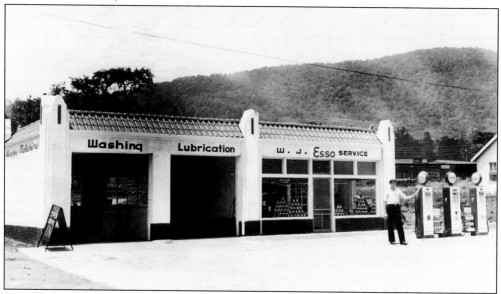

Mace Dollar owned the West Jefferson Esso station. Currently, this is the location of Hale Tire. Big Jim Scott is standing at the gas pumps. He was well over seven feet tall and wore shoes that were sized in the 20s. The West Jefferson stockyard can be seen in the background. (Courtesy of John Reeves.)

This is the first location of the Western Auto store in West Jefferson. Glenn Little owned and operated the store for a long time. Apparently, this building has been torn down, and few residents remember it. (Courtesy of the Ashe County Public Library.)

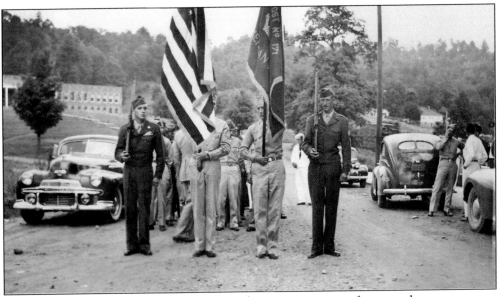

This wonderful photograph depicts a group of veterans preparing for a parade or a ceremony near the community building in West Jefferson. In the background is the West Jefferson School. (Courtesy of the Ashe County Public Library.)

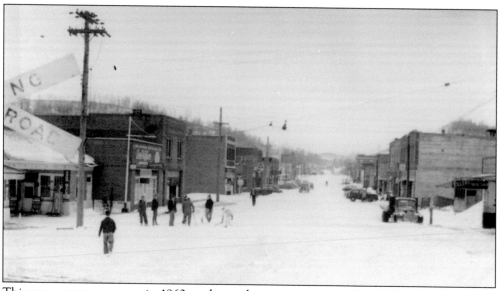

This was a common scene in 1960, and on other occasions, too. West Jefferson's elevation is 2,979 feet, and it receives almost 14 inches of snow yearly. The 1960 snow was an anomaly, with snowfalls occurring five weeks in a row, resulting in drifts between five and twenty feet in many places. (Courtesy of the Ashe County Historical Society.)

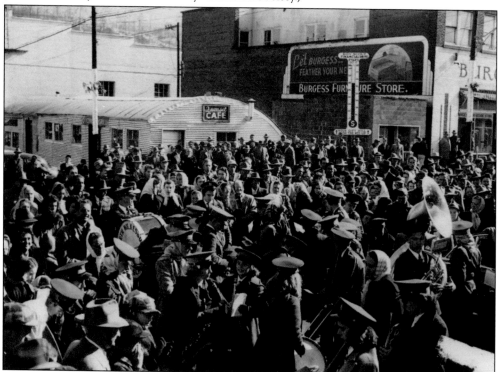

West Jefferson's Quonset Cafe was the most unique building in town. It was owned by Herbert Francis, whose mother operated the restaurant. The lower section of the Quonset hut was a small grocery store. To the right of the hut is a small cinderblock building. This was the first location of the Friendly Shoe Store. (Courtesy of the Ashe County Public Library.)

Three

CHURCHES AND SCHOOLS

The principle cornerstones of life in Ashe County have always been the importance of Christian worship and the need to educate children. From the time of the settlers, one-room schoolhouses were situated in remote hollers and valleys, making education accessible where travel was very restricted. Neighbors gathered to hold services of worship whenever possible. Therefore, it is no surprise that churches and schools were essential elements in the early planning stages and in the minds of those drawn to the new and vital West Jefferson area.

In 1912, a group of 15 people gathered to hold organized worship. This was the nucleus of what would become the First Baptist Church. Small groups of worshippers that would evolve into the Mount Jefferson Presbyterian Church and West Jefferson United Methodist Church began meeting in 1925 in hastily thrown-together venues. The three largest churches in West Jefferson grew out of these humble beginnings. Today, the congregation of each of these churches numbers in excess of 300 members. In the bustling environment that has become West Jefferson, other opportunities for worship have become available. These include the Cornerstone Fellowship, the Calvary Baptist Church, the West Jefferson Church of Christ, and the Church of the Nazarene.

Meeting the desire to educate the children of the new town was a particular challenge. Until the early 1900s, education throughout the county was the responsibility of individual families, who hired teachers to instruct children in the home, and small schools established in various valleys. During the period from 1915 to 1916, the Baptist church operated a school in West Jefferson. The building that was used as a dormitory to house students attending from rural parts of the county was totally remodeled in 1956 and is today Badger Funeral Home. In 1915, the West Jefferson founders took action to establish a school district in the new town, and construction on the first school building was completed in 1917. In 1923, the school was turned over to the county and state and became accredited. After many changes through the years, following World War II, the West Jefferson schools merged with other county schools.

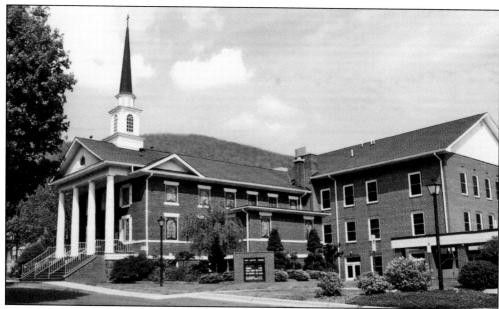

West Jefferson Baptist Church is seen here as it exists today. This structure is the result of several renovations to the original building, constructed in 1930–1931. Though the exact date of the congregation's origin is unknown, a business meeting held in 1912 noted the intention to borrow money to build a church. Around 1915, a Sunday school meeting was held in an old depot building downtown. The first land purchase involved property where the West Jefferson School was later located, but no building was ever erected. In 1916, the First Baptist Church was constituted under the leadership of Rev. George Reeves. From 1915 through 1925, the church experienced high times and low times under a series of pastors. At some time between 1916 and 1925, a wooden structure was built on College Avenue that served as the church. (Courtesy of Joy Campbell.)

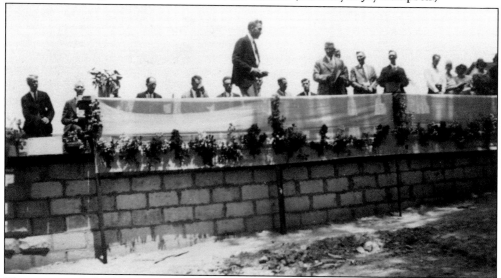

The cornerstone for the West Jefferson Baptist Church was laid in 1930, and the church building was completed in 1931. The cornerstone was reported to contain, among other memorabilia, a glass vase containing a silver dollar, a violet, and a piece of paper with the names of the deacons. Here, Rev. Coy Blackburn reads scripture at the dedication ceremony. (Courtesy of Joy Campbell.)

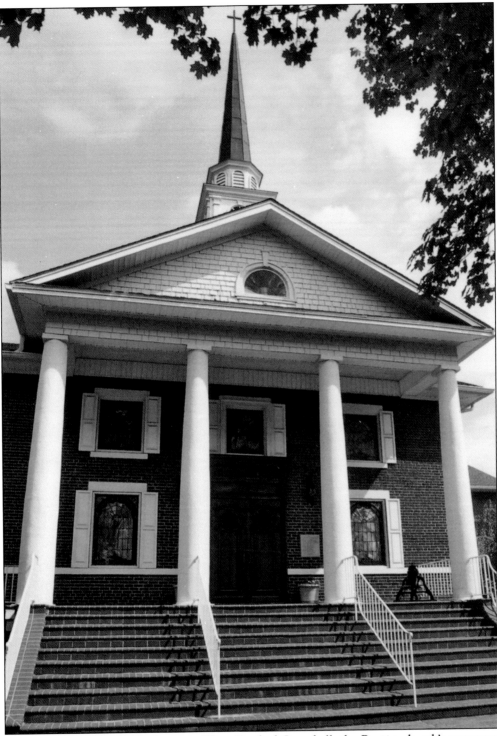

Around 1949, under the leadership of Rev. Rexford Campbell, the Baptist church's sanctuary was remodeled and the educational building was added. This photograph, taken from across the street, shows the entrance to the sanctuary. (Courtesy of Joy Campbell.)

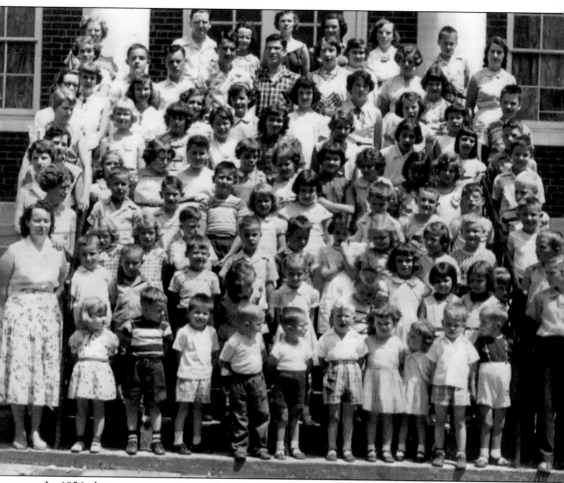

In 1956, during a very active and vigorous period of the church's development, Sunday school classes were held for all ages. In addition, there were two Sunday services and a Wednesday-night prayer service. Posing here is the 1956 Vacation Bible School class. (Courtesy of Joy Campbell.)

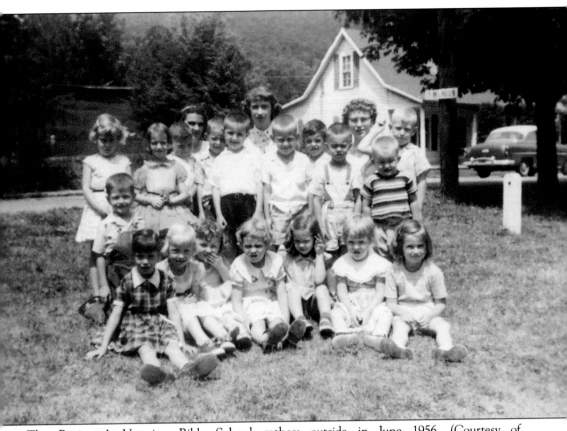

The Beginner's Vacation Bible School gathers outside in June 1956. (Courtesy of Joy Campbell.)

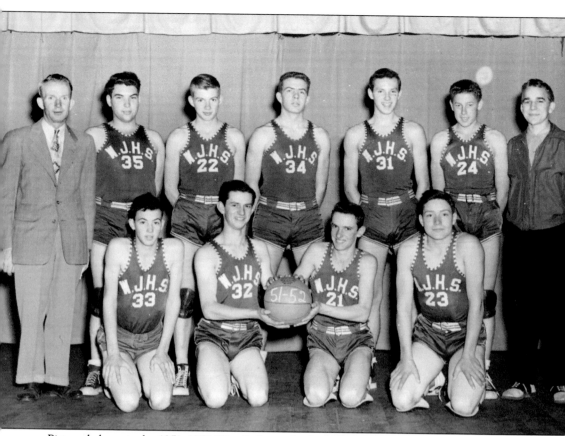

Pictured above is the 1951–1952 West Jefferson basketball team. (Courtesy of the Ashe County Historical Society.)

This is the West Jefferson United Methodist Church as it exists today. The sanctuary is the building on the right. The large attached building on the left, known as Hensley Hall, houses meeting rooms, Sunday school rooms, and a large hall used by both the church and local organizations to hold special events. (Courtesy of the West Jefferson United Methodist Church.)

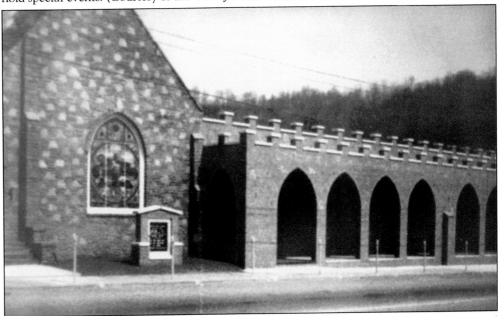

The Mount Jefferson Presbyterian Church, seen here in its current building, was first constituted at West Jefferson on July 12, 1925. At the time, and for another year, services were held in the old Carolina Theater on Jefferson Avenue. In 1926, a 75-foot-by-75-foot lot was purchased on Jefferson Avenue, and a tent was erected for the purpose of holding services. The first event held under the tent was a Christian Chautauqua. (Courtesy of John Reeves.)

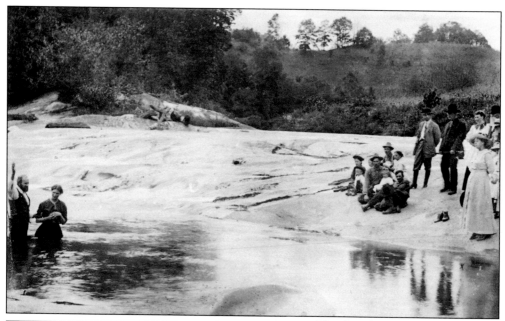

This Ray family photograph shows a baptism on the New River. Purportedly, West Jefferson citizens wanted to be baptized in the river and traveled some distance to be part of this service. (Courtesy of Beth Ray Schroeder.)

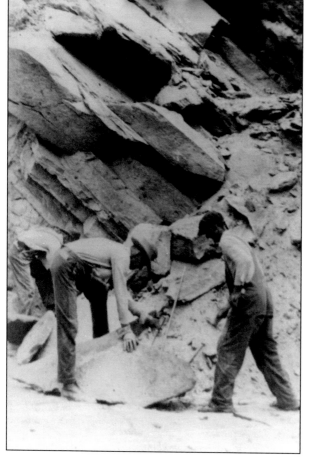

In 1927, the dream to create a permanent, stone Presbyterian church building took the first steps toward realization when the rock began to be quarried. The local source of the rock was at a place now off the Blue Ridge Parkway, called the "Jumping-Off Place." (Courtesy of John Reeves.)

The first stones are being laid for the new Presbyterian church's sanctuary. (Courtesy of John Reeves.)

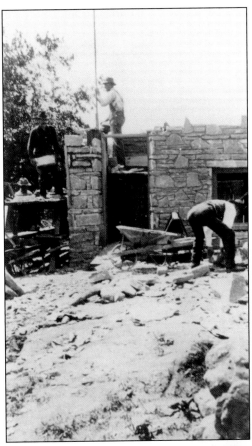

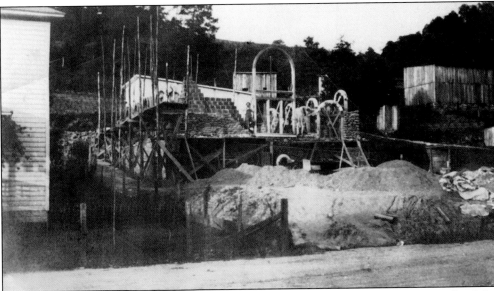

The original wooden church is visible on the left in this photograph of the eastern side of the stone construction. Revenue for the construction was provided through local money drives. (Courtesy of John Reeves.)

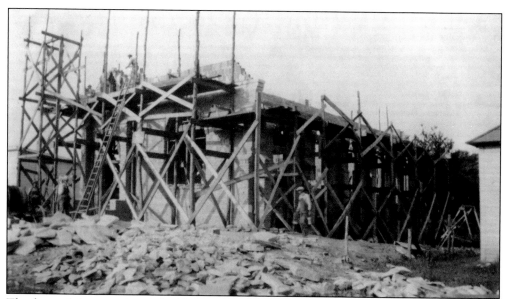

The front of the new church building is shown under construction. Just visible on the right is the original wooden church building. Through the generosity of Presbyterian churches in nearby cities, money and materials were given to the project. Among the donated items were interior pieces such as pulpits, brass railings, collection plates, an art-glass window, and other windows needed to complete the project. (Courtesy of John Reeves.)

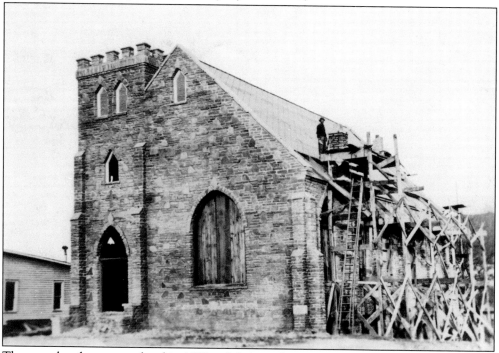

The new church was completed in 1927 and dedicated at services conducted by the Rev. Roger E. Caldwell of Winston-Salem. The congregation considers the church building a source of constant thanksgiving and a visible manifestation of a friendly church dedicated to serve the spiritual needs of the town. (Courtesy of John Reeves.)

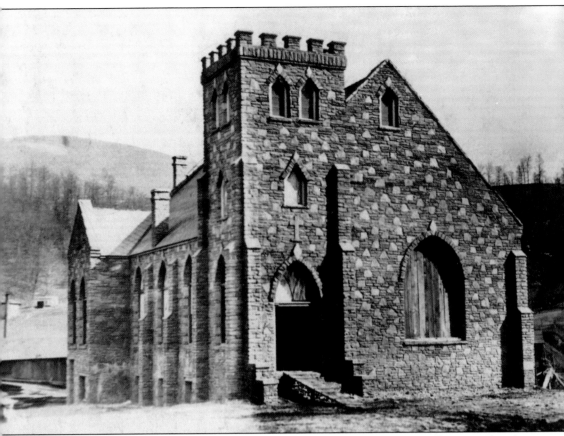

In 1961, West Jefferson Presbyterian Church was renamed Mount Jefferson Presbyterian Church after merging with Jefferson Presbyterian and Obids Presbyterian Churches. In 1976, work was begun on an addition to the church. The addition houses meeting space and Sunday school rooms. A recent renovation project added a wheelchair ramp and a new front door treatment. (Courtesy of the West Jefferson Presbyterian Church.)

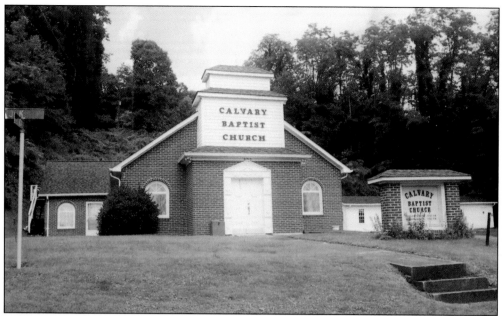

Calvary Baptist Church was voted into existence in August 1960 by members of a portion of the West Jefferson community. At the time, the congregation of 10 people from the community voted to join the Ashe Baptist Association when the church became a reality. A piece of property was purchased in September 1961 for the new church. In 1963, a church bell was added, and in 1978, additional property was purchased for parking. (Courtesy of Carol Williams.)

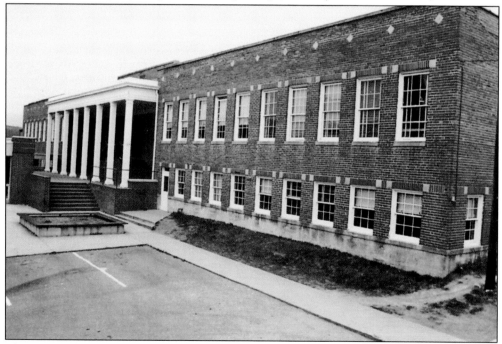

The West Jefferson School building is seen here in an earlier form. Many renovations and changes over the years altered the building's appearance. The high school was consolidated into Beaver Creek High School in the early 1950s. (Courtesy of Carol Williams.)

This is a view of the school building as it looks today. It is currently used as an alternative school and as a day care center, Learning Thru Care. (Courtesy of Carol Williams.)

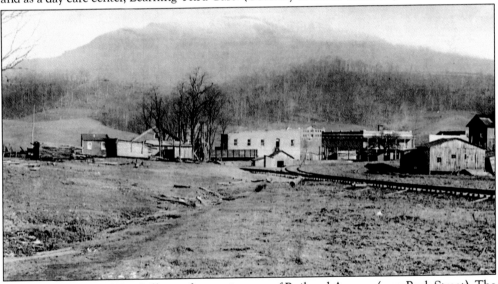

This is a view across West Jefferson from a site west of Railroad Avenue (now Back Street). The school building is visible in the distance, between the large building on the left now housing WJ Hardware and the brick Old Hotel across the street on the right. The site was home to a number of school buildings from 1915 until a single elementary school replaced the previous elementary and high school buildings. Until the schools were constructed, in 1915–1916, a school was operated by Baptists. The Baptist Denominational School had an enrollment of approximately 75 students. About 1923, the Baptists turned over the building to the county, and it was later given to the state. It became an accredited high school around 1923. (Courtesy of the Ashe County Public Library.)

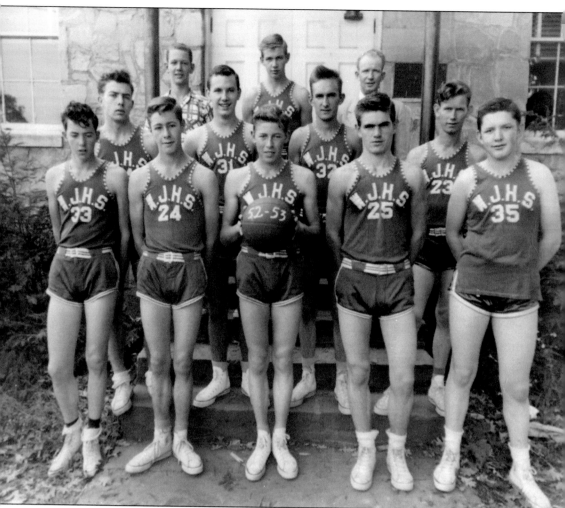

The 1952–1953 basketball team was the last at West Jefferson High School. The school was consolidated with Fleetwood and Elkland Schools into Beaver Creek High School. Pictured, from left to right, are (front row) Clifford Miller, Tony Hardin, Arveson Wyatt, Thomas Hooper, and A.B. Weaver; (middle row) Gale Hurley, Ritz Ray, Connie Burgess, and Bill Goodman; (back row) Wayne Goodman, D.J. Hart, and coach Bob Davis. (Courtesy of the Ashe County Historical Society.)

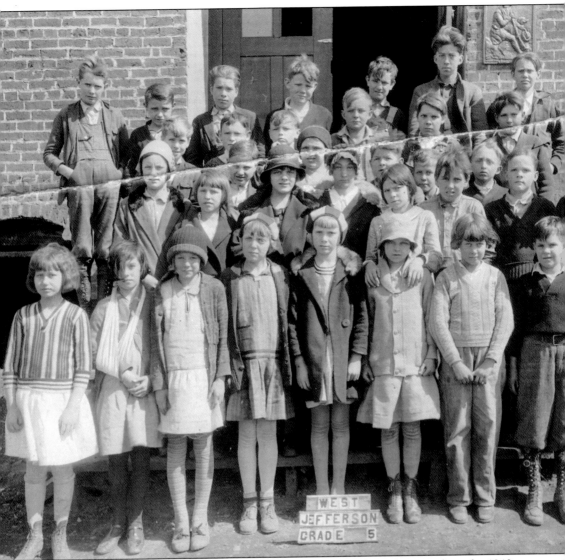

This is a fifth-grade class at West Jefferson High School, posing for a photograph in the 1940s. Note the sign on the school indicating that this building was a WPA project. (Courtesy of the Ashe County Historical Society.)

Through the years, many changes were made to the school buildings. About 1933, a gymnasium was constructed. In 1947, the school board acquired the funds to install a central heating system and to implement improved sanitary conditions. Enrollment by 1934 had grown to about 150 students. (Courtesy of Dale Baldwin.)

This class photograph at the West Jefferson Elementary School was taken just a short time before consolidation. (Courtesy of the Ashe County Historical Society.)

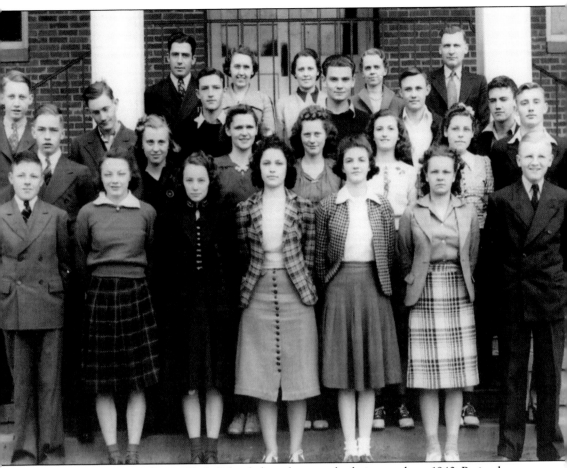

This is another West Jefferson High School class photograph, dating to about 1940. Posing here are the members of a graduating class. (Courtesy of the Ashe County Historical Society.)

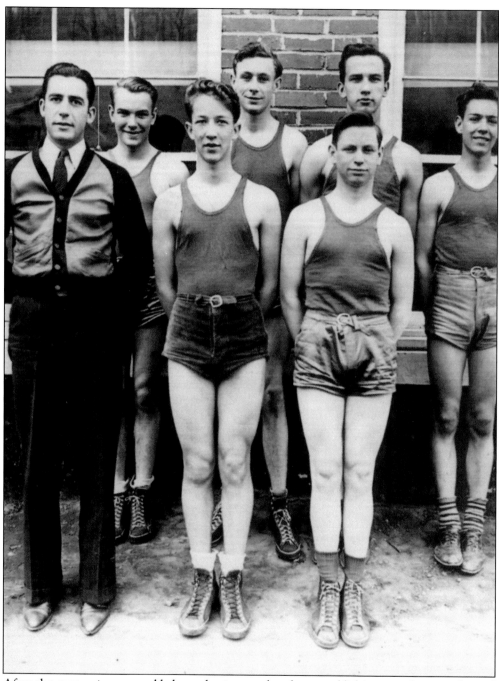

After the gymnasium was added, emphasis was placed on establishing an adequate physical education program. Soon, basketball became the major sport in the school. This boys' basketball team was coached by Paul Perkins in 1940. (Courtesy of the Ashe County Historical Society.)

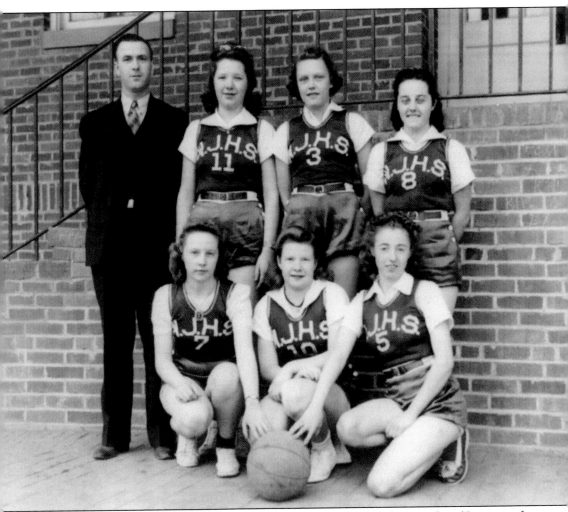

A girls' West Jefferson basketball team from the 1940s poses for the photographer. (Courtesy of the Ashe County Historical Society.)

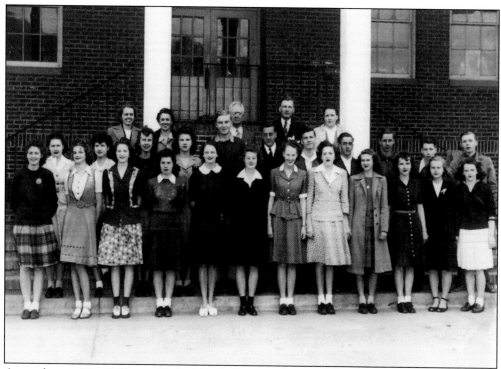

An exuberant West Jefferson High School class poses in the mid-1940s. (Courtesy of the Ashe County Public Library.)

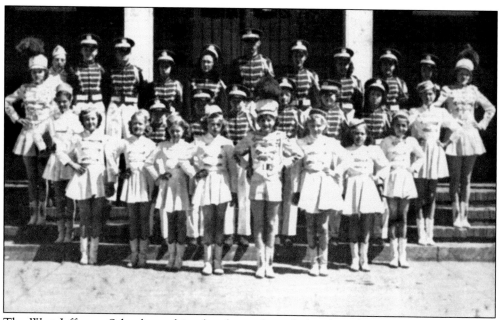

The West Jefferson School marching band was the only band in the county during the late 1940s and early 1950s. (Courtesy of John Reeves.)

Four

FRIENDS, NEIGHBORS, AND HOMES

A pictorial presentation of the history of a town such as West Jefferson would, of course, include the town's commercial structures, past and present, along with photographs of schools, churches, factories, shops, and streets. More than anything else, a town is a place where people live, work, play, worship, and govern themselves.

With the coming of the railroad, the area that became West Jefferson offered opportunity. When the train made its first run to West Jefferson, there were already many people to receive it. Among these folks was Stamper Richardson, who had a large boardinghouse in the settlement. Other early notables in West Jefferson included Rufus Parsons and his sons, Otto and Coy; the George Oliver family; and the James Gambill family. The following are names found in historical accounts: Edd and Daisey Parker Jones; the T.E. Parker family; Dr. Clifford and Amma Horne Ray; the James Allen Sr. family; the Fields Sheets family; Elihu McNeill; Prof. R.E. Plummer; Dr. Edgar Dow Jones; storekeepers Mack and Fannie Bare Poe; and the Hamilton family. John A. Weaver Sr. came to live in West Jefferson in 1914. Isaac Faw, son of Bynum and Georgia Koontz Faw, had a large boardinghouse in West Jefferson that was a landmark because of its relatively large size.

This chapter is a presentation of photographs featuring some of the people who are associated with the town's early history or who later lived in West Jefferson as it became an important commercial center for northwestern North Carolina.

Pictured here are town aldermen in the 1950s–1960s. They are, from left to right, Carl Graybeal, Russell Barr, Hugh Crigler, Rex Morton, and Earl Graybeal. These town leaders and West Jefferson businessmen are enjoying snacks and West Jefferson–bottled Dr. Peppers as a special occasion has gathered them together. (Courtesy of John Reeves.)

Anne Shoemaker (McGuire) and Buddy Blackburn pose with Trigger at the Shoemaker house around 1949. (Courtesy of Anne McGuire.)

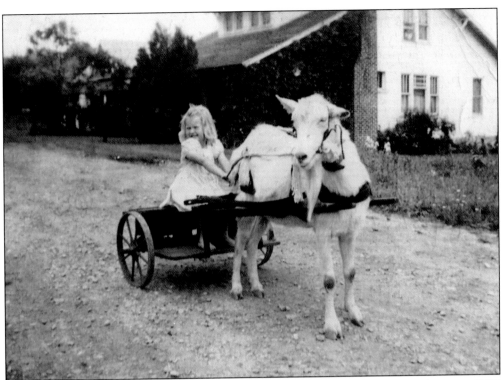

This photograph shows Anne Shoemaker in Pine Medley's goat cart. The Edgar Jones house is in the background. Small towns such as West Jefferson were once dotted with "country ways" and "country situations," including vegetable gardens and farm animals. (Courtesy of Anne McGuire.)

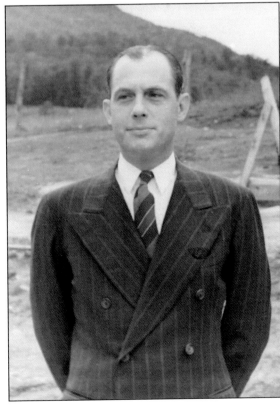

Dr. J.K. Hunter was an early dentist in the town of West Jefferson. He practiced there for many years and was an active part of the community. (Courtesy of the Ashe County Public Library.)

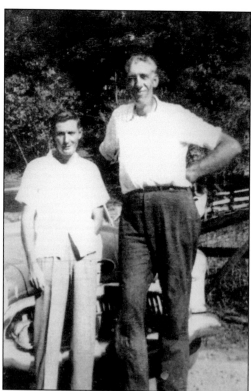

Big Jim Scott, who worked in West Jefferson and was well known in the town, was actually from the Grassy Creek community. Scott was well over seven feet tall and worked in circuses and other entertainment jobs in the area. His very large shoes were on display in the shoe-repair shop for many years. (Courtesy of John A. Weaver.)

At a Belk's Department Store Christmas party in the late 1950s are, from left to right, Virginia Myers, who was later a mayor of West Jefferson; Doris Graybeal; Vita McNeil Blevins; Sharpe Shoemaker, the store manager; Mable Colvard; Betty Greene Gentry; and Ruth Gentry. (Courtesy of Anne McGuire.)

Pictured here are Bill and Pearl Brown. Bill was at one time a co-owner with Earl Hardin of the Parker Tie Company. Bill's large collection of tools is on permanent display in Ashe County's Mountain Farm Life Museum at the Ashe County Park. (Courtesy of Rick Brown.)

Posing here in what may be poor versions of Easter bonnets are businessmen Robert Pugh (left) and Sharpe Shoemaker. Pugh was with the Ashe Super Market in the early 1950s, and Shoemaker was with Belk's from 1937 to 1968. Did these two ever imagine that this photograph would appear in a book like this? Credit must be given to them for being such fun-loving, good sports, whatever the occasion. (Courtesy of Anne McGuire.)

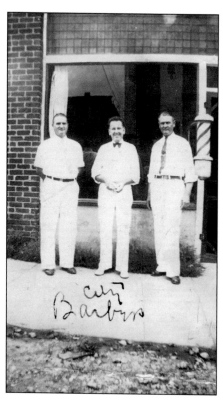

Here, three local barbers pose in front of their shop in West Jefferson. They are T.B. Grayson (left), Jim Haire (center), and Conrad Hayden Burkett. (Courtesy of the Ray family.)

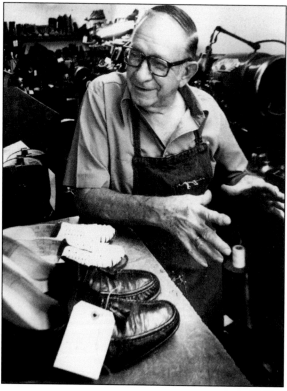

D.G. Stout is seen here inside his famous and important cobbler shop. Stout continued working in his business until a very old age. A very valuable member of the West Jefferson community, he is greatly missed. Note the tagged shoes on the table, ready for folks to pick up. (Courtesy of Jerry Brown.)

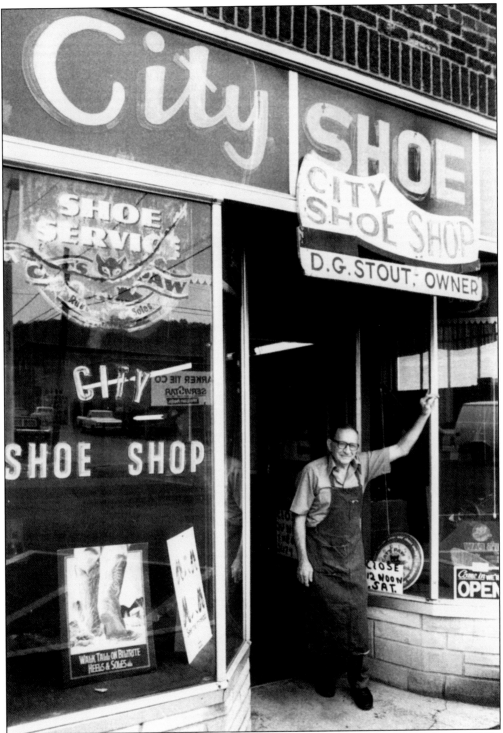

D.G. Stout stands in front of his shoe-repair business, the City Shoe Shop, probably in the 1950s. Stout was very skilled, and a visit to his shop was also a lesson in congeniality. (Courtesy of Jerry Brown.)

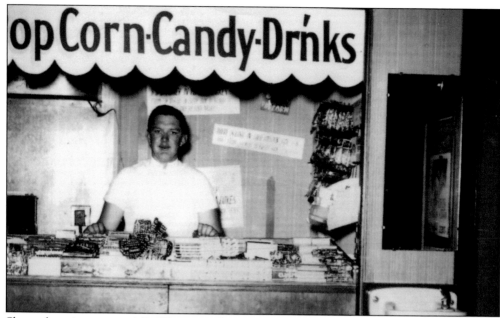

Shown here is a young A.B. Weaver working concessions at the Parkway Theater, located on Main Street in West Jefferson. In subsequent years, Weaver served as a Methodist minister. Upon his return to West Jefferson from the church circuit, he was elected mayor. Known for his loquacious nature and wit, Weaver was the first voice heard on West Jefferson's radio station, WKSK, in the late 1950s. He is a member of North Carolina's Order of the Longleaf Pine, awarded for his years of community service. (Courtesy of John Reeves.)

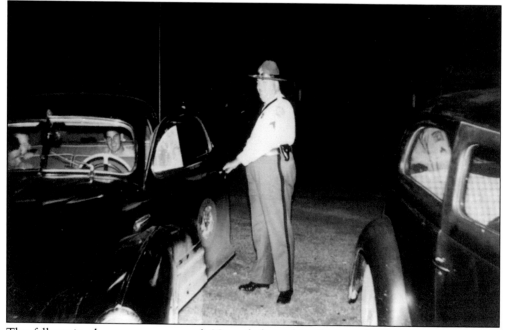

The fellows in the car seem amused. Nevertheless, this photograph shows North Carolina highway patrolman David Houston giving a ticket to some teenagers in the 1950s. (Courtesy of Dale Baldwin.)

Pine Medley was a well-known local character on the streets of West Jefferson. He worked at the local cattle market and on several local farms for many years. Medley was a blacksmith during World War I. (Courtesy of Jerry Brown.)

This photograph features Estel Miller, a West Jefferson policeman. Miller is standing across from the old location of the First National Bank, at the corner of Jefferson Avenue and Main Street in the middle of town. (Courtesy of the Ashe County Public Library.)

Bob Morgan (left) and unidentified friends are seen here on Jefferson Avenue. The Morgans are related to the Bares, the Littles, the Severts, and the Davises. They lived along Jefferson Avenue. (Courtesy of Keith Hartzog.)

Charlie Davis was owner and operator of the famous Charlie's Diner, which occupied a genuine dining car. It was last located on Jefferson Avenue. Here, Davis is, of course, about to rob his bees. (Courtesy of Keith Hartzog.)

This photograph shows Cora Morgan and her grandson Keith Hartzog. The Morgans once lived in a brick structure where Miller's Insurance is now located. (Courtesy of Nancy P. Edwards.)

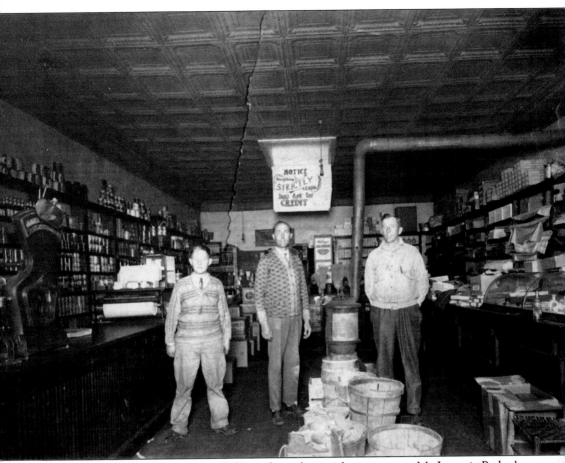

Gene Parker (center) and his son Glen (left) are shown here with a customer, a Mr. Jones, in Parker's Grocery Store. Glen Parker later became active in the real estate business, eventually partnering with George Burgess to form Parker-Burgess Realty. (Courtesy of the Burgess family.)

Gene Parker was a very successful businessman in the early days of West Jefferson. He operated a grocery store and a real estate business. (Courtesy of Nancy P. Edwards.)

West Jefferson Hotel is shown here in the early 1980s. It was still a very busy location, with many businesses located within the building. The offices of the local newspaper, the *Jefferson Times*, are shown here. The *Times* merged with the *Skyland Post*, becoming the *Jefferson Post*. (Courtesy of the Ashe County Public Library.)

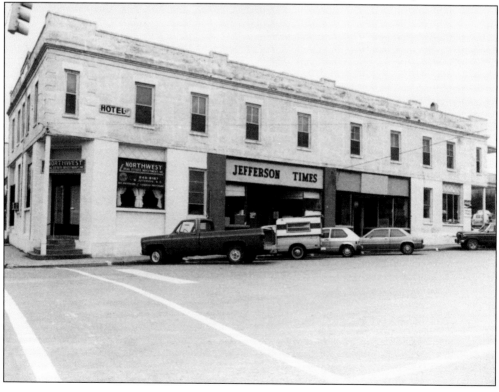

Glen and Kathleen Graybeal pose for a photograph. Glen was a Jefferson businessman and a veteran of World War I. (Courtesy of Anne McGuire.)

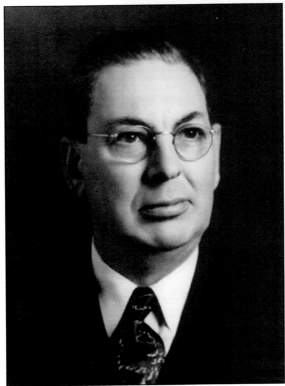

Glen Graybeal is seen here in a formal portrait. West Jefferson had been an incorporated town for just a few years when the United States entered World War I. Graybeal was a veteran of that war. (Courtesy of Mary McIntyre.)

Shown here at a birthday party in April 1946 or 1947 are, from left to right, (first row) Sara Little, Phyllis Yount, Nancy Barr, Daphne Terry, Ronnie Goodman, and Dickie Little; (second row) Sarah Henry McLaurin, Beverly Little, Anne Shoemaker, and Joyce and Nancy Parker; (third row) Pat McMillian, Sara Hunter, Nancy Hughes, Buddy Dollar, Billy Jim McEwen, and Frank Colvard. Mount Jefferson is seen in the background. (Courtesy of Anne McGuire.)

Fifth-graders from West Jefferson Elementary School pose with their teachers, Lola Myers (top, center) and Nancy Barr (top, right). The students are, from left to right, (first row) Joyce Gilley and Betty McNeill; (second row) Anne Shoemaker, Kay Wiles, and Sammie Gentry. (Courtesy of Anne McGuire.)

On the steps at the Seagraves' house are, from left to right, Sharpe Shoemaker, LaVern Johnson, J.L Seagraves, Mrs. Wade Eller, Mrs. LaVern Johnson, and Mrs. J.L. Seagraves. J.L. was president of First National Bank. (Courtesy of Anne McGuire.)

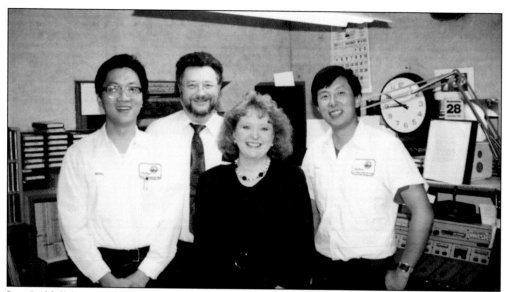

Jan Caddell (second from left) poses in the control room at the WKSK radio station with Karen Powell and visitors from China. For many years, Caddell has hosted the *Happy Time Show*, a morning talk show that promotes community activities, agencies, and charities. He is active in the North Carolina Broadcasters Association and is a past president. Caddell has participated in local fundraising campaigns such as that for the Veterans Memorial at the new courthouse. An excellent master of ceremonies at special events, Caddell is also a well-known part of the "Greenfield Jam Sessions" on Friday evenings, playing his harmonica. (Courtesy of WKSK.)

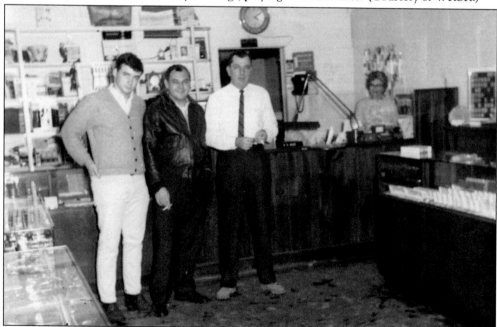

Friends gather inside the Wiles Jewelry Store. Jerry McMillan (left) served later as an air traffic controller at the Atlanta airport, and is currently active in West Jefferson with many community activities. Also seen here are Bobby Walker (center) and Ed Roland. Hazel Wiles is minding the store. (Courtesy of Judy W. Graham.)

This is a photograph of Harold "Bud" and Jo Stringer. Harold was an accountant for the local cattle market and served as town manager for West Jefferson for a number of years. Jo was a hairdresser at the Mayflower Beauty Shop on Jefferson Avenue. (Courtesy of Anne McGuire.)

Posing with an ambulance are Joe Williams Sr. and his son Joe Jr.. Joe Sr. was owner and operator of ambulance and cab services in West Jefferson. He is also the father of James Williams, who has served as West Jefferson police chief and is currently the high sheriff of Ashe County. (Courtesy of the Williams family.)

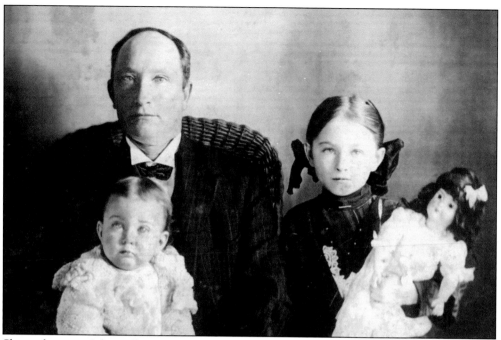

Shown here are John Kilby Reeves's grandfather Benjamin Everett Reeves and his daughters Catherine (left) and Ruth, who started the *Skyland Post* newspaper. (Courtesy of John K. Reeves.)

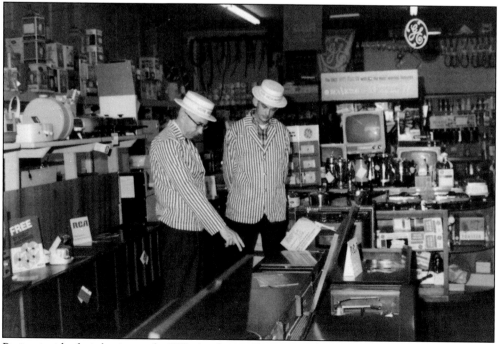

Posing inside their business, the W.J. Appliance Store, are John Reeves (left) and his son, John Kilby Reeves. They are dressed for a special RCA television promotion. This business began in 1948. (Courtesy of John K. Reeves.)

Charity Barr was the wife of Robert Barr, a leading West Jefferson businessman, and taught at West Jefferson High School for several years. (Courtesy of John Reeves.)

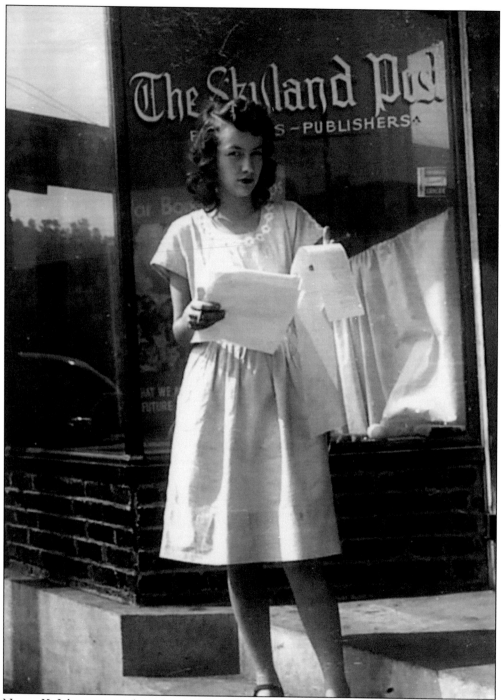

Nancy K. Johnston stands in front of the office of the *Skyland Post*, the news media in Ashe County for over 50 years. Many of the photographs in this book come from the files of that newspaper. (Courtesy of the Ashe County Public Library.)

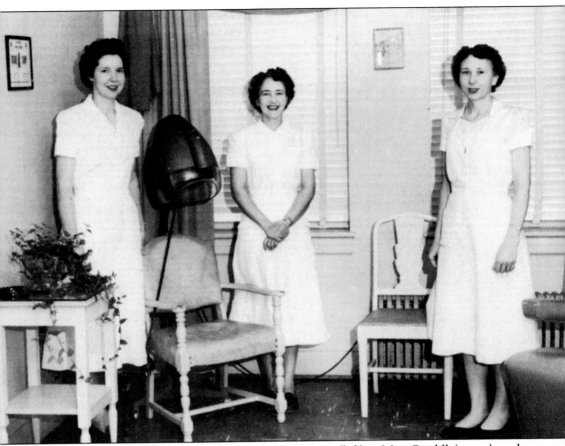

Seen here in the Mayflower Beauty Shop are Jo Stringer (left), a Mrs. Caudill (center), and Mildred Atwood. (Courtesy of Anne McGuire.)

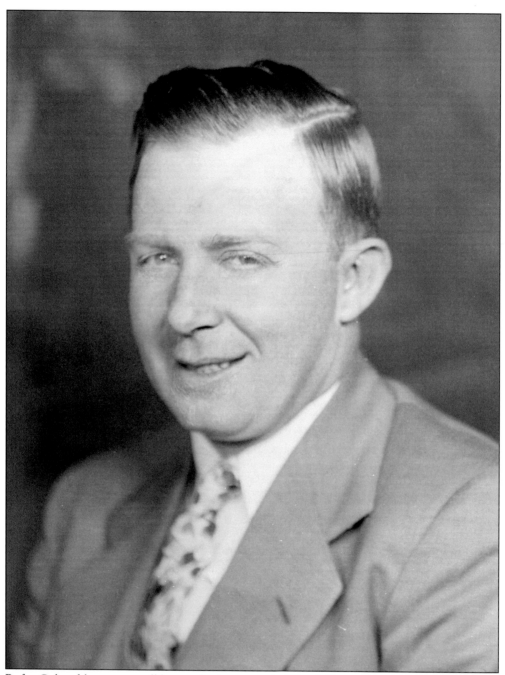

Rufus Colvard became a well-known businessman in West Jefferson. He was a banker, service station owner, heating-oil distributor, and operator of a hotel/restaurant. (Courtesy of the Ashe County Public Library.)

Pictured in the late 1940s are J.C. and Lillie Seagraves with Anne Shoemaker (McGuire). (Courtesy of Nancy P. Edwards.)

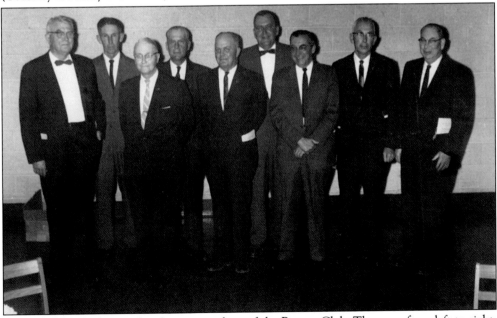

This photograph depicts the charter members of the Rotary Club. They are, from left to right, Raymond Francis, Wick Vannoy, Ira T. Johnston, "Doc" Hunter, Ed Barr, Sharpe Shoemaker, Dean McMillan, John Reeves, and Glen Graybeal. The Rotary Club's work has led to the establishment of the Ashe County Park, the local fiddler's convention, the college scholarship program, and the Ashe County Sports Hall of Fame. (Courtesy of Anne McGuire.)

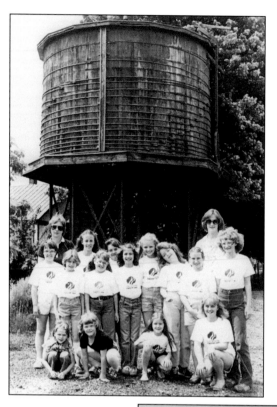

These Girl Scouts, led by JoAnn Woodie (back left) and JoAnn Goodman (back right), are protesting the removal of the railroad water tank. (Courtesy of JoAnn Woodie.)

Stella Anderson (right) poses here with Evelyn Shoemaker. For many years, Anderson was the publisher of the *Skyland Post* newspaper in West Jefferson. She was one of the founders, in 1948, of the West Jefferson Woman's Club and was at one time on the board of trustees of the University of North Carolina at Chapel Hill. (Courtesy of Anne McGuire.)

Hazel Chipman Wiles stands next to the Wiles home. The Hardin house is in the background. Hazel and Don Wiles moved to West Jefferson to run their jewelry store, and they became very involved in the community. They reared three daughters—Donna Marlyn, Judith Chipman, and Ellen Karen. (Courtesy of Judy W. Graham.)

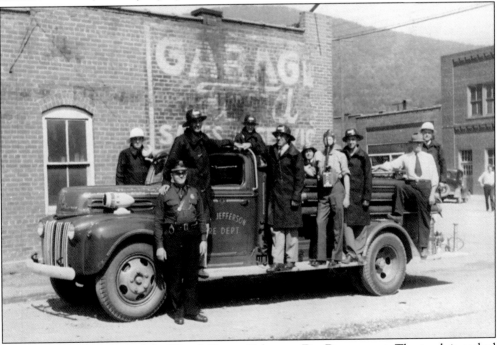

Posing here are members of the West Jefferson Volunteer Fire Department. The truck is parked in front of what was the Ford dealership at that time. The location is now home to the town hall offices. (Courtesy of the Ashe County Historical Society.)

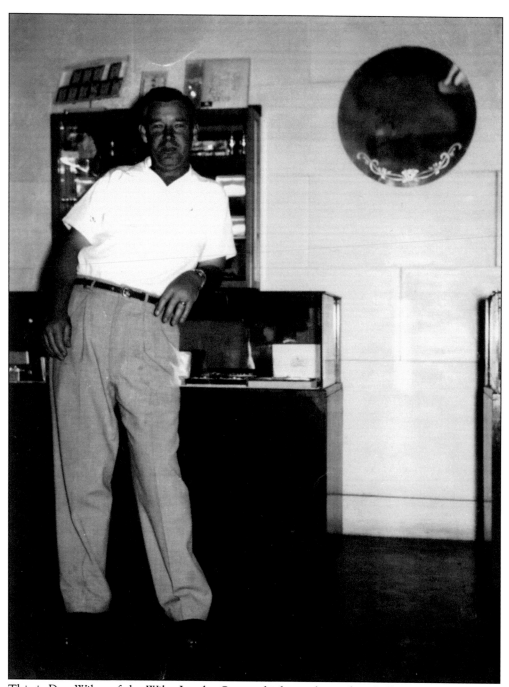

This is Don Wiles, of the Wiles Jewelry Store, which was located on Jefferson Avenue. Wiles operated his business for 30 years, starting in 1946. He was especially active in the Lions Club, as well as in the West Jefferson Volunteer Fire Department, the Ashe County Rescue Squad, and the Ashe Wildlife Club. (Courtesy of Anne McGuire.)

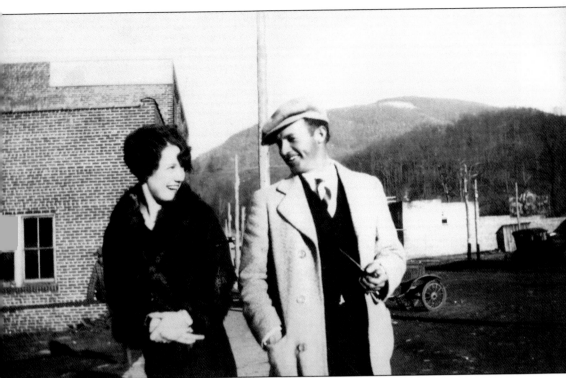

A young Rufus Colvard is shown here with Josephine Osborne. Rufus and his wife operated the Colvard Manor Hotel in West Jefferson. As a young man, he came back to the mountains from a job with Wachovia Bank to go into business with his father, William Edgar Colvard. These business ventures included the West Jefferson Chevrolet Company, Colvard Oil Company, Phillips 66 service stations in several counties, car washes, and tire-recapping businesses. (Courtesy of John Reeves.)

This is Ruth Reeves Wilson, daughter of Dr. B. Everette Reeves and Pauline Welborn Reeves. The Dr. B.E. Reeves family lived at the end of Wilton Avenue in one of the earliest brick homes built in West Jefferson. Dr. Reeves moved to West Jefferson in 1918. (Courtesy of John Reeves.)

Dr. Ritz Clyde Ray poses with his granddaughters. Quite successful as a physician, Dr. Ray had his practice in an office in the middle of town, on Jefferson Avenue, fronted by Ray's Drug Store. (Courtesy of Beth Ray Schurster.)

Dr. B.E. Reeves came to West Jefferson in 1918, but already had a practice in the area. He served for a while in the North Carolina Legislature, where he was the chairman of the committee on public health. The 1899 legislature was known as the "Historic Legislature of 1899," perhaps because much progress was made to improve public health. Dr. Reeves opened an office in town, but he had been well known before that for riding out on horses, one of which was named Charlie, into the country from house to house, announcing his approach with a loud "Hello!" Folks would come out of their homes and tell Dr. Reeves whether his services were needed. Dr. Reeves administered to people with the instruments and medicines he carried in saddlebags. (Courtesy of the Ray family.)

Dr. R.C. Ray and his wife, Bobbie, are shown here with their son Ritz. Following in his father's footsteps, Ritz also became a physician, specializing in psychiatry. He lives in Winston-Salem. The Ashe Civic Center sits on property donated by the Rays. Folks still like to tell "Dr. Ray" stories. (Courtesy of the Ray family.)

Bert Jones was one of West Jefferson's first mayors. He was also one of the earliest postmasters. His daughter Bobbie was the wife of Dr. Ritz Clyde Ray and the mother of Ritz Jr. (Courtesy of the Ray family.)

Later businessmen and farmers, the Ray brothers are pictured here. They are, from left to right, (front row) Ritz and Earl; (back row) Fred and Clifford. The Ray Hardware Store was a West Jefferson landmark and a convenient, friendly place to purchase many things, from nails to paint to plants. In the spring, items were sold on the steps above the sidewalk. (Courtesy of the Ray family.)

This is the Dr. R.C. Ray house, located on Wilton Avenue in West Jefferson. (Courtesy of the Ray family.)

Mr. and Mrs. Moses Graybeal are seen in this photograph. The portraits on the wall depict, from left to right, grandchildren Myrtle Dean, Elizabeth, and Bernard B. (Courtesy of Mary McIntyre.)

Shown in this very early photograph are members of the Graybeal family. They are, from left to right, (seated) Bernard and Glen; (standing) twins Earl and Carl. (Courtesy of Mary McIntyre.)

Belva and Gale McMillan pose in front of their home on Church Street. Belva was a teacher, and Gale operated the W.J. Parts Company. (Courtesy of Sarah McLauren Bacon.)

Sharpe Shoemaker presents an agricultural award to the son of a German family that once lived in Ashe County. This award was sponsored by the Rotary Club. (Courtesy of Anne McGuire.)

This is Bradshaw Myers of the West Jefferson Barber Shop. Myers was the father of local historian Rufus Myers. Bradshaw's wife, Lola Landreth Myers, was a teacher in the West Jefferson Elementary School. (Courtesy of Rufus Myers.)

This photograph shows Scoutmaster Gale McMillan and his son Phil. Gale McMillan was very prominent in the Boy Scouts of America organization. He was given the Silver Beaver award for his work with the Scouts. (Courtesy of Phil McMillan.)

Belva McMillan, a fourth-grade teacher at West Jefferson Elementary School, is pictured here with her sons, Phil (right) and David. David McMillan became CEO of the well-known Forsythe Memorial Hospital in Winston-Salem. (Courtesy of Phil McMillan.)

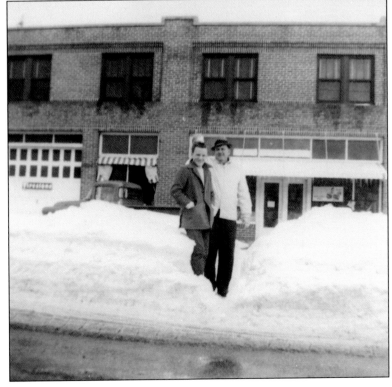

Sharpe Shoemaker (right) stands in the snow with Bradley McNeill, who later became the first principal of the consolidated Ashe County High School. McNeill now serves on the board of directors of Blue Ridge Energies. (Courtesy of Vita Blevins.)

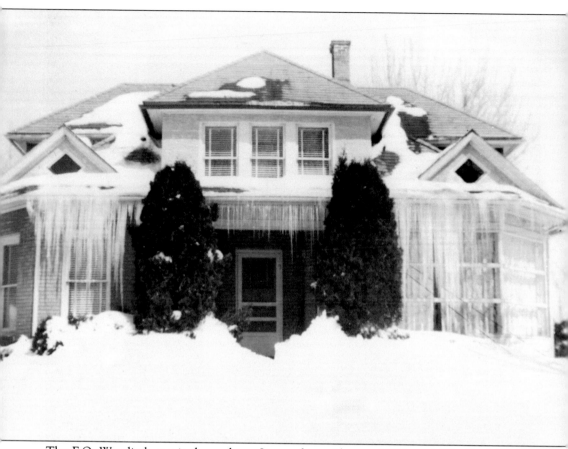

The E.O. Woodie home is shown here. It was the residence of E.O. and Ella Black Woodie and their four children. It is now the home of Vance and Thelma Woodie. (Courtesy of JoAnn Woodie.)

Gene Hafer (left), Wayne Sells (center), and Clay Woodie are the boys in this photograph. Hafer was once a paperboy in West Jefferson. His father operated the Chevrolet dealership in town for a number of years. Now an attorney, Hafer is known for his work with nonprofit organizations, his association with the Ashe County Historical Society, and his research into the life and accomplishments of Tam Bowie, one of the founders of West Jefferson. Hafer maintains homes in Raleigh and Ashe County. (Courtesy of Gene Hafer.)

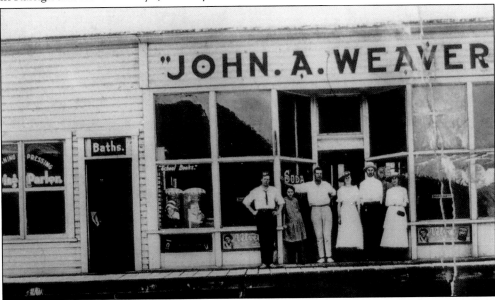

Shown here is the John Andrew Weaver family: John A. (second from right) his wife, Clyde Faw Weaver (third from right), and their children. John A. Weaver, a "man of many trades," had considerable commercial property in West Jefferson. At various times, he ran a café, a barbershop, and a taxi company, and he was active in construction. Weaver favored "the attributes of reinforced concrete," and his buildings have stood the test of time. He was known in his later years for his letters to the editor of the *Winston-Salem Journal*. (Courtesy of John Weaver Jr.)

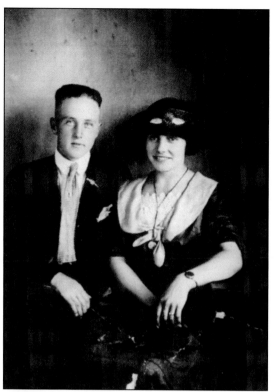

Everette Osco and Ella Black Woodie pose for a photograph. Osco's rise to prominence is as dramatic as any story of a successful young man of the early 20th century. He began by doing all sorts of work, from shining shoes to working in sawmills, until the idea of buying a bus came to him. After paying off a loan for the first bus, Woodie expanded his services, eventually building a little transportation "empire" in parts of four states—North Carolina, South Carolina, Virginia, and Tennessee. (Courtesy of JoAnn Woodie.)

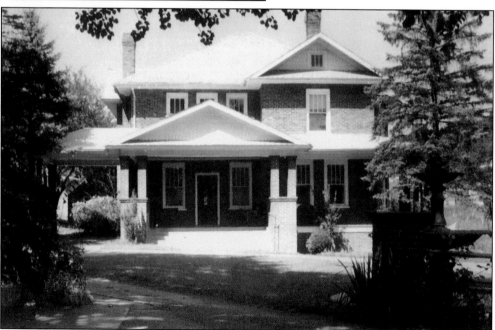

This is the old Dr. B.E. Reeves home, built around 1920. The structure is made of brick that was manufactured on-site. The property features a fountain shipped by train from New York, tennis courts, and a pond. The house is currently the residence of Haskell and Anne McGuire. (Courtesy of Anne McGuire.)

One of West Jefferson's most well-known artists is Stephen Shoemaker. Recognized for his detailed, dry-brush watercolor paintings of steam locomotives, Shoemaker has many other pieces of art to his credit. He maintains a studio in West Jefferson. One of his works is seen by people as they come into West Jefferson toward Jefferson Avenue on approach from the four-lane highway between the towns. One of Shoemaker's latest projects is the book *Stephen Shoemaker, the Paintings and their Stories*, that he has published along with Janet Pittard. Shoemaker and a number of others are responsible for the remarkable diorama of the train the Virginia Creeper, which ran through Ashe County, into the town of West Jefferson, and beyond. The display is located at the Museum of Ashe County History in the 1904 Courthouse. (Courtesy of Anne McGuire.)

These young folks from West Jefferson are participating in a Belk's Department Store fashion show. They are, from left to right, (bottom row) Virginia Parrish and David Shoemaker; (top row) Becky Pugh Burgess, Barbara Edwards, and Edith McNeill. (Courtesy of Anne McGuire.).

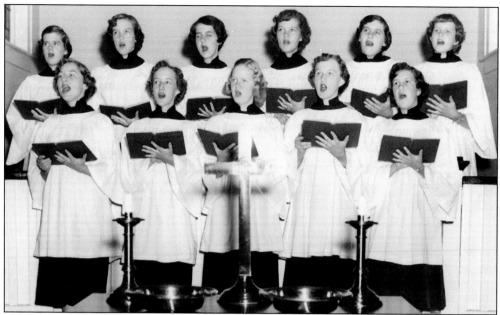

The West Jefferson Methodist Church Youth Choir is seen here in 1953. These young women are, from left to right, (first row) Becky Pugh Burgess, Nancy Parker Edwards, Peggy Joyce Davis Taylor, Joyce Parker Tucker, and Carrol Wyrick Howell; (second row) Lucy Long Miller, Sarah Hunter Speers, Patsy McMillan, Nell Ray Duval Bare, Louise Long Cashion, and Anne Shoemaker McGuire. (Courtesy of Anne McGuire.)

This was the home of Don Blackburn and his family. It is located on the corner of Wilton Avenue and Fourth Street. The house later became the residence of Dr. Carson Keys. (Courtesy of Anne McGuire.)

Outings to Hungry Mother Park near Marion, Virginia, were popular with West Jefferson youth. Seen here in the 1950s are, from left to right, (first row) Dot McMillan, Kay Wiles, and Pat McMillan; (second row) David McMillan, Hobie Davis, James Davis, Phil McMillan, and Janice Myers. (Courtesy of Anne McGuire.)

Pictured here, perhaps in the early 1960s, are youngsters in an early, private kindergarten taught by Edith Lindsey (top left) and Evelyn Shoemaker (top right). Readers of this publication may be able to name some of these children. Perhaps some readers recognize themselves! (Courtesy of Anne McGuire.)

Buddy Blackburn, whose father operated Blackburn's Department Store in West Jefferson, went on to become a successful construction company owner. (Courtesy of Anne McGuire.)

Shown here is Fair Payne, sister of Jimmy and Nan. She retired after a career as a registered nurse and lives in Tennessee. Her father, Harvey Payne, was known for his years of work with the Kraft Cheese plant in West Jefferson. Later, the facility became Ashe County Cheese, which has stood for many years on Main Street. (Courtesy of Anne McGuire.)

This photograph features the children of Earl Graybeal. They are, from left to right, Nancy Graybeal Byrd, Earl Jr., and Mary Graybeal McIntyre. (Courtesy of Mary McIntyre.)

This is a young Bill Woodie on Beauty at the E.O. Woodie homeplace. Bill, just like his father, could be seen riding horses all around town. (Courtesy of JoAnn Woodie.)

Bill Woodie is shown here in his Augusta Military Academy uniform. The son of E.O. Woodie, Bill, along with Bill Ashley, began the Greenfield Restaurant. The name for the restaurant was suggested by Elizabeth Speers Barlow, a local English teacher who founded the Ashe County Little Theatre. The Greenfield Restaurant operated from 1964 to 1996. (Courtesy of JoAnn Woodie.)

Perhaps the envy of Piedmont youngsters, West Jefferson kids usually have plenty of sledding opportunities. It once was possible, as shown here, for sledders to be seen in town, on Main Street. This photograph shows Barr Hill. Among the sledders identified here are David McMillan, Hobie Davis (later the director of the Skyline Telephone Membership Corporation), James Davis (later a teacher in Independence, Virginia), Phil McMillan, and Anne Shoemaker. (Courtesy of Anne McGuire.)

Five

WEST JEFFERSON
THEN AND NOW

West Jefferson, North Carolina, has gone through many changes over the 100 years since its founding. What started as a stop on the new railroad line coming in from Abingdon, Virginia, soon became the largest town in Ashe County.

Many notable businesses have called West Jefferson home throughout the years. Restaurants included the Bloody Bucket, Charlie's Diner, and the Green Lantern; department stores included Rose's, Belk's, Jefferson House, Hubbard's, and Davidson's; the farm and hardware stores were Ray's Hardware and Bare & Little's Feed; automobile dealerships included GFP Chevrolet, Twin City Chevrolet, Superior Pontiac, and Northwestern Dodge; and manufacturing facilities included West Jefferson Wood Products and Phoenix Chair Plant.

Many businesses continue to have a long history in West Jefferson, including Badger's Funeral Home, Parker Tie Company, Smithey's Restaurant, Parkway Theater, Ashe County Cheese, Bantam Chef Restaurant, Leviton/Southern Devices, and WJ Hardware. Many newcomers have become staples of the town, including Ashe Federal/Lifestore Bank, Friendly Shoe Store, and Geno's Restaurant.

This final chapter offers a "walking tour" of West Jefferson, complete with current addresses. It is hoped that these more current photographs of the buildings in town, with detailed descriptions of their origins and former tenants, will help bridge the gap between history and the historic town of West Jefferson, North Carolina.

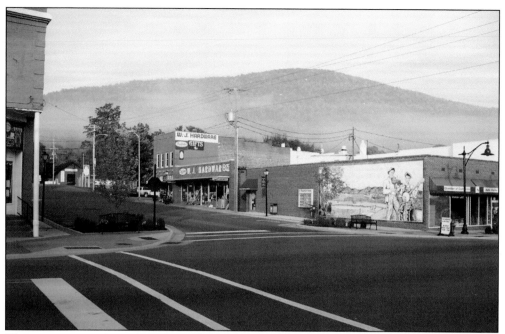

The tour starts at the intersection of Main Street and Jefferson Avenue. West Jefferson's most well-known building, the Old Hotel (left), occupies one corner, while one of the many murals in the downtown area is visible on the Visitors Center building on the other corner. (Courtesy of Brian Jones.)

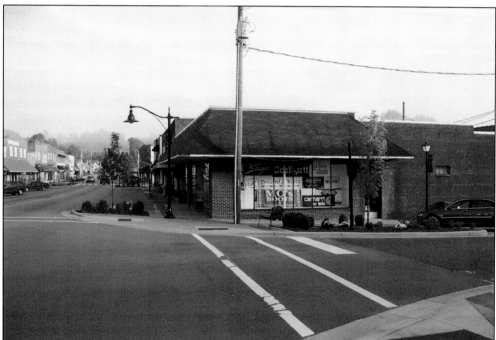

The other corners of Main Street and Jefferson Avenue are occupied by the West Jefferson Town Hall and Mo's Boots. The boot store is now in the building that McNeil's Department Store occupied for many years. (Courtesy of Brian Jones.)

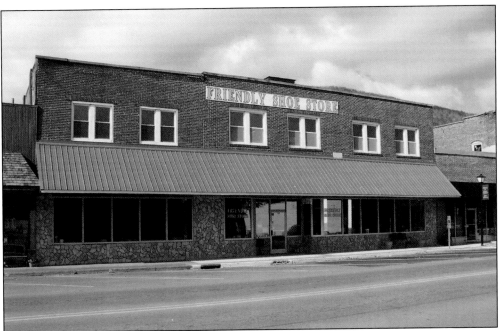

Just north of Main Street, at 13 North Jefferson Avenue, is Ralph Little's Friendly Shoe Store. The building started as Blackburn's Department Store, then was Rose's until that business built a new structure "between the towns." Little moved in when Rose's moved out. (Courtesy of Brian Jones.)

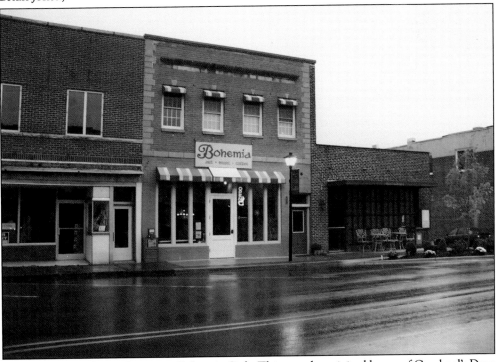

At 106 North Jefferson Avenue is Bohemia Cafe. This was the original home of Graybeal's Drug Store. (Courtesy of Brian Jones.)

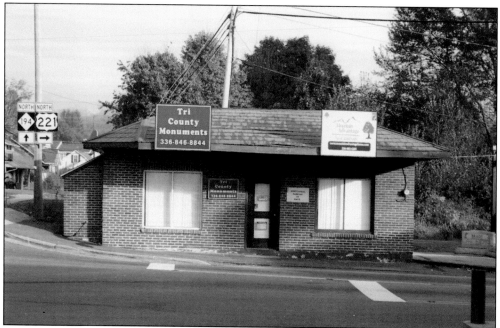

At the intersection of Jefferson Avenue and Second Street stands Tri-County Monuments, formerly Ashe Monument Works. The lot was once the site of a Standard Oil gas station. The Virginia Creeper train ran just behind this building before turning onto Back Street toward the West Jefferson depot. (Courtesy of Brian Jones.)

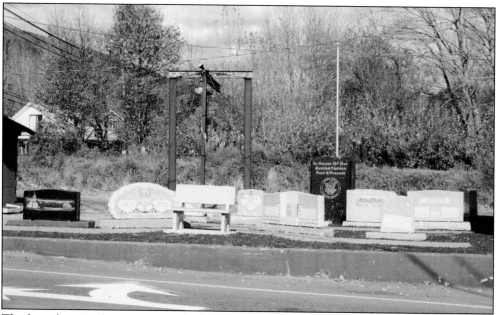

The large base in the monument display yard is a dedication to past and present members of the armed forces. The base originally held the statue known as *Pocahontas*. The statue was commissioned and rejected by the City of Geneva, New York, in the 1930s due to a dark vein running through the figure's face. It was brought to West Jefferson when the monument store opened, and it was sold in the 1980s. (Courtesy of Brian Jones.)

112

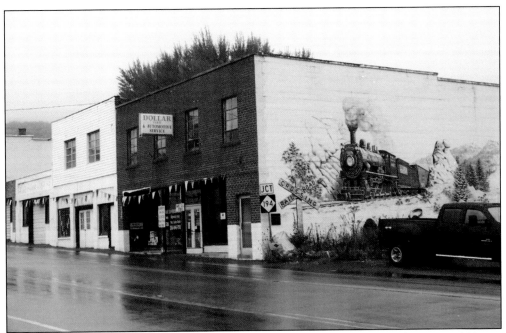

Dollar Tire is at 107 East Second Street. The building originally housed Badger Funeral Home, until the funeral home moved to its current location in the 1930s. Another of the town's many murals, depicting the Virginia Creeper, decorates this building. At one time, the train was Ashe County's link to the outside world. (Courtesy of Brian Jones.)

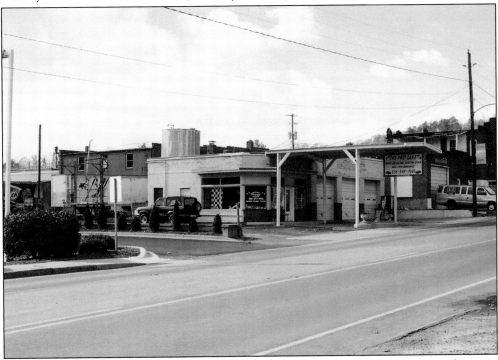

Across from Dollar Tire is the Fast Lane. The building was Pete Medley's gas station for many years. (Courtesy of Brian Jones.)

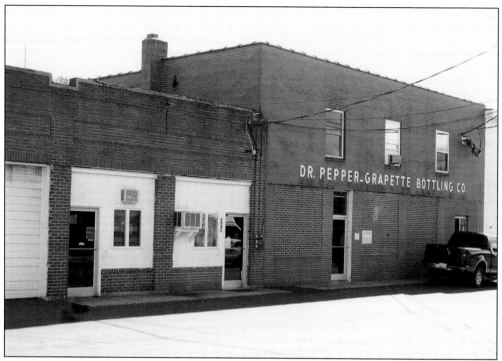

Situated on West Third Street, the Dr. Pepper bottling plant in West Jefferson is seen here. (Courtesy of Brian Jones.)

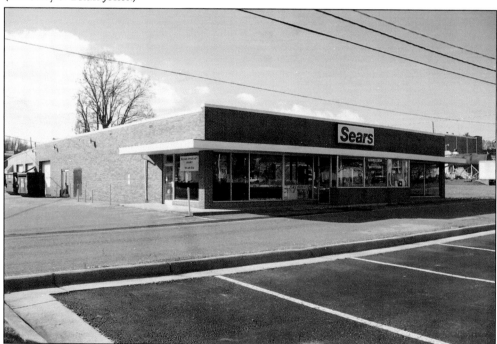

Turning right on Sixth Avenue, a visitor will come to the Sears catalog store. Having gone through several owners over the years, the store has nevertheless remained a constant fixture of West Jefferson's retail landscape since opening in the 1960s. (Courtesy of Brian Jones.)

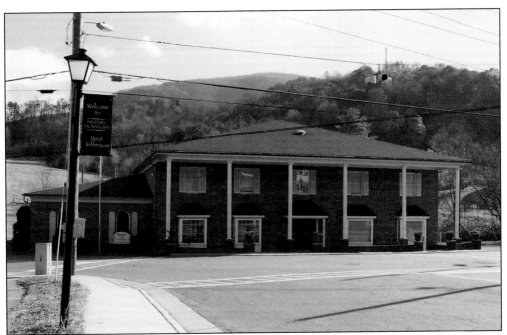

At the intersection of Sixth Avenue and Main Street stands the current home of Badger Funeral Home, Ashe County's longest–continuously operated business. This building originally served as a dormitory for the former West Jefferson High School, located on the hill behind it. (Courtesy of Brian Jones.)

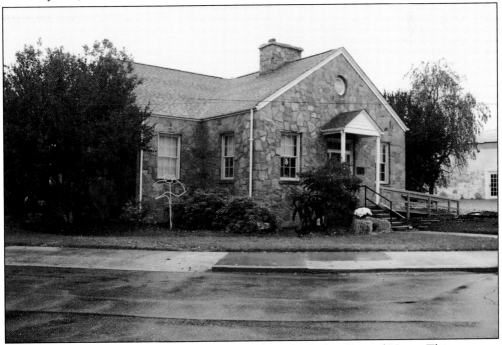

The Ashe County Arts Council is located across from the Badger Funeral Home. This structure was built in the 1930s by the Works Progress Administration (WPA). It housed the Blue Ridge Opportunities Commission (BROC) and a community center. (Courtesy of Brian Jones.)

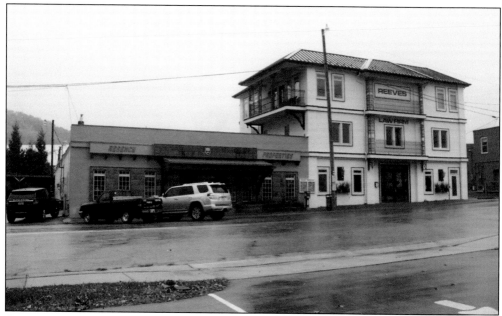

Continuing on Main Street, one comes to Regency Properties/Reeves Law Firm. The building was once a part of Parker Tie and also housed the former Ashe Savings and Loan. Later, Farmers Cooperative Exchange (FCX) and Southern States occupied this location. When the Reeves Law Firm bought the building, it added the third floor and remodeled the entire facade. (Courtesy of Brian Jones.)

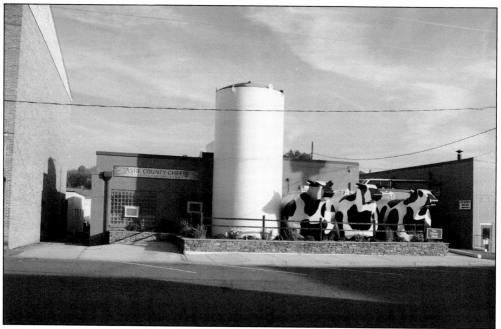

Also on Main Street is Ashe County Cheese. This is North Carolina's oldest cheese-making plant, operating since the 1930s. It was previously a part of the Kraft Cheese Company. The three large milk storage tanks were made to look like cows a few years ago by the high school welding class. (Courtesy of Brian Jones.)

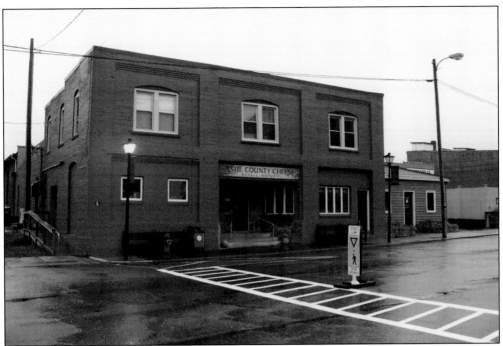

Across the street from the cheese plant is the Ashe County Cheese retail store. The building previously housed Ashe Wholesale Grocery, as well as the offices for Central Telephone Company. (Courtesy of Brian Jones.)

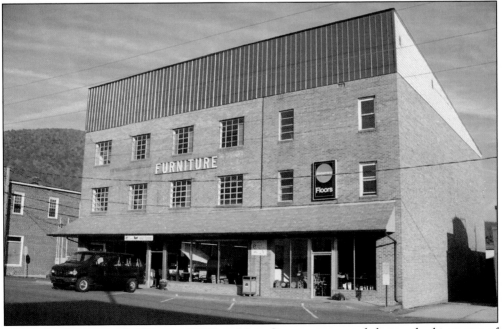

This large three-story building at 109 East Main Street was erected during the big snows of 1960. It was owned by Burgess Furniture, then McNeil's Furniture, and now houses an Amish Furniture store. It was built on the site of the Bloody Bucket Restaurant, one of West Jefferson's first eateries. (Courtesy of Brian Jones.)

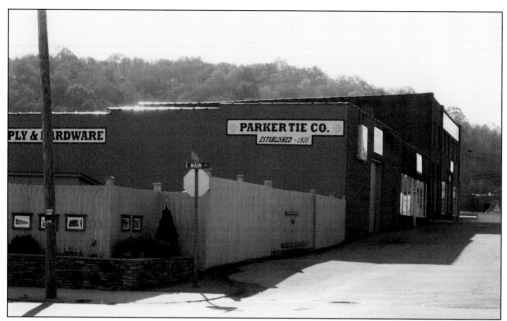

On South Third Avenue stands Parker Tie Company. It has occupied this block since the 1940s. The company has expanded and renovated the buildings, which were formerly a second location of the Ashe Savings and Loan Company. (Courtesy of Brian Jones.)

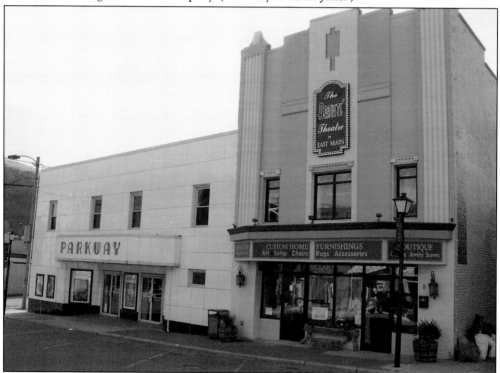

The Parkway Theater, built adjoining the original theater building, is now known as The Artists' Theatre. The local Ford dealer originally stood in this location until moving to its current address. (Courtesy of Brian Jones.)

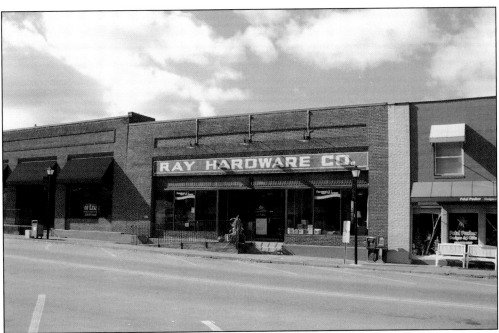

Turning south on Jefferson Avenue, one comes to the Ray Hardware Company building. Ray Hardware was owned and operated by Bud and Zip Ray until their deaths. It was auctioned off and became the home to Sally Mae's Emporium for several years. It is now the Florence Thomas Art School. (Courtesy of Brian Jones.)

At 102 South Jefferson Avenue is Mountain Outfitters. The building was the home to Farmers Hardware, then Burgess Used Furniture Store. It then served as a warehouse for Bare & Little's Company, and then it was Sweet Aromas Bakery. (Courtesy of Brian Jones.)

Boondocks Restaurant is at 108 South Jefferson Avenue. It was originally owned by Wick Vannoy, who bought and sold hams, chickens, eggs, and so forth. Later, Belk's Department Store moved here from down the street where Friendly Shoe Store is. Then, in the 1990s, Subway Restaurant and other stores shared the building; followed by Fraser's Restaurant in 2003 and Boondocks in 2011. (Courtesy of Brian Jones.)

Farther down Jefferson Avenue is Geno's Restaurant. This building was erected by the Rhodes family for their Rhodes Furniture Store. Later, the building housed Gateway TV Store, and then Geno's. Visible on the side wall is another of the downtown murals. (Courtesy of Brian Jones.)

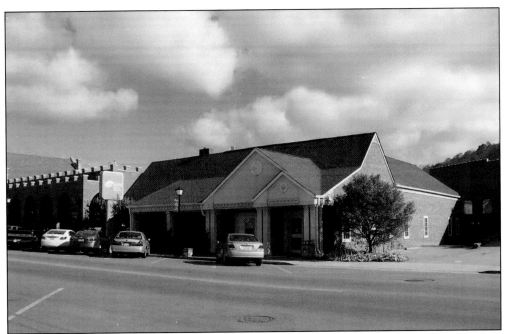

The West Jefferson branch of Lifestore Bank is at 205 South Jefferson Avenue. The building was erected for Ashe Savings and Loan after the bank left the Parker Tie building. Ashe Federal Bank remodeled it and changed its name to Lifestore in the 2000s. Earlier, this site housed a gas station, which was torn down to make room for the banks. (Courtesy of Brian Jones.)

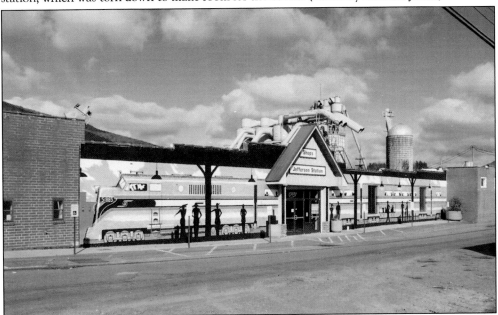

Jefferson Station occupies a large section of this part of town. It was the Phoenix Chair Plant, which was purchased by Thomasville Furniture in 1964. Thomasville closed this factory in 1990. It was later turned into a combination of apartments, shopping, and commercial spaces named Jefferson Station. This photograph of the Hice Avenue entrance to the shops shows another of West Jefferson's murals. (Courtesy of Brian Jones.)

The Bantam Chef Restaurant, at 401 South Jefferson Avenue, has been a part of the West Jefferson landscape for many years. (Courtesy of Brian Jones.)

Just farther south stands the building that housed the *Skyland Post*, the county newspaper from the early 1930s until 1988, when it merged with the *Jefferson Times* to create the current *Jefferson Post* newspaper. The *Skyland Post*'s Mrs. Ed M. Anderson was a well-known publisher who enjoyed statewide prominence. This building currently houses the offices of a medical practice. (Courtesy of Brian Jones.)

Blue Ridge Golf Cars operates out of this building at 500 South Jefferson Avenue. The building housed the local Chevrolet dealership after it moved from the intersection of Jefferson Avenue and Ashe Street. The dealership erected a new building on Mount Jefferson Road in 2006. (Courtesy of Brian Jones.)

This is the Farmers Burley Warehouse on Long Street. Formerly one of the places Ashe County farmers came to sell their tobacco crops, it now houses a utility trailer supplier and a pine-roping and wreath-making factory. The latter business is an extension of the Christmas tree farms that have become a major source of income for the county. (Courtesy of Brian Jones.)

Perched on a hill overlooking town, the Ashe County Public Library welcomes all those in search of knowledge. In 2008, the library went through a major renovation, including the addition of the two-story section on the back and the new entrance. During renovations, the library was moved into Jefferson Station, allowing the public to continue enjoying its services. (Courtesy of Brian Jones.)

The West Jefferson Municipal Cemetery is also on the hill above town, adjoining the library and West Jefferson Park. The large white mausoleum visible to the left of the sign belongs to the Bowie family, one of the major players in the founding of West Jefferson. (Courtesy of Brian Jones.)

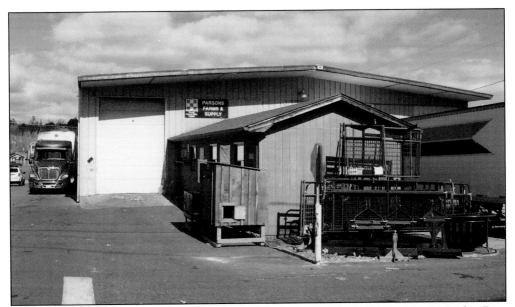

Parsons Farms & Supply occupies a large part of Back Street. The building was operated as Bare & Little Company for many years. Across the street once stood the West Jefferson depot for the Virginia Creeper train. That location is now an additional warehouse for Parsons Farms. (Courtesy of Brian Jones.)

Just behind the old hotel on Back Street is the Backstreet Park. Occupying a section of the old train bed, the park was built in the first decade of the 21st century. It features a walking trail up the hill to the library, as well as a covered stage where free concerts are held each month during the summer. (Courtesy of Brian Jones.)

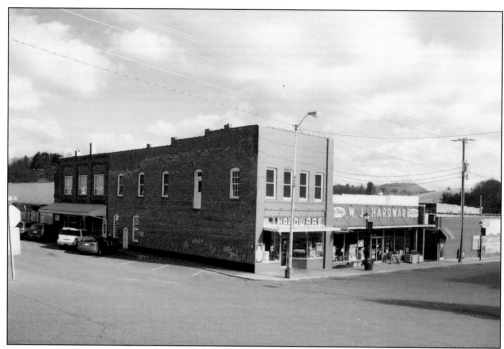

Across Main Street from the hotel stands one of the oldest businesses in West Jefferson, W.J. Hardware. The door visible on the left side formerly led to a set of stairs up to the office of Dr. Reeves. It is now a part of the store. (Courtesy of Brian Jones.)

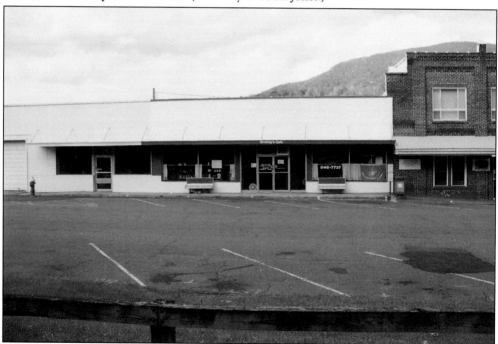

Smithey's Restaurant on Back Street has been a staple of West Jefferson for many years. Its signature "Smithey" burger, a small breaded hamburger, is known far and wide. Many people remember getting a sack of them for a dime each in the earlier days. (Courtesy of Brian Jones.)

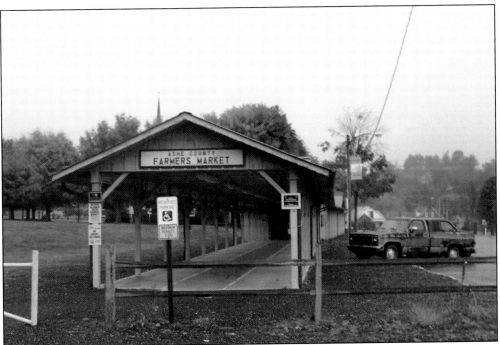

The Ashe County Farmers Market is located on the train bed just above Back Street, north of Main Street. It comes alive each Saturday morning as local farmers bring their bounty into West Jefferson to share with the public. (Courtesy of Brian Jones.)

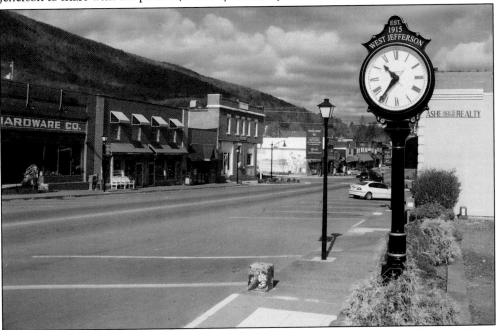

This November 2013 photograph of downtown West Jefferson, with a view looking north on Jefferson Avenue, was taken on a recent bright Sunday morning. The renovations and updates to the streets of the town are evident. West Jefferson continues to be a progressive place to live and work. (Courtesy of Brian Jones.)

DISCOVER THOUSANDS OF LOCAL HISTORY BOOKS FEATURING MILLIONS OF VINTAGE IMAGES

Arcadia Publishing, the leading local history publisher in the United States, is committed to making history accessible and meaningful through publishing books that celebrate and preserve the heritage of America's people and places.

Find more books like this at
www.arcadiapublishing.com

Search for your hometown history, your old stomping grounds, and even your favorite sports team.